Vermont

Art

Guide

By Ric Kadour & Christopher Byrne

The information contained in the *Vermont Art Guide* has been researched and confirmed at press time. However, things change; art venues come and go, get new phone numbers, change website addresses, or simply move. Please know that every effort was made to provide accurate information.

Please share your experience using the *Vermont Art Guide* with us. You can send your comments and suggestions to:

Kasini House
PO Box 1025
Burlington, VT 05402

Or email info@kasinihouse.com

Thank you for your feedback.

Cover design by Ric Kadour
Photographs by Ric Kadour

ISBN: 0-9771397-0-0

Printed in Vermont by Capital City Press, Montpelier
First Edition/First Printing

Table of Contents

Acknowledgements

The authors would like to thank a number of individuals without whose support this book would not have happened: Our dear friends and family, Marietta Pomainville, Yvon Goguen & Mongo Bearwolf, Mark Sohlstrom & Gary Brunell, Matt Partalis, Liza Sacheli, Denise Altland, Ray & Debbie Rusak; Brandy Altland-Comas for her publishing expertise; Rob Schumann for his willingness to share his wisdom; Studio Place Art's Sue Higby, Firehouse Gallery's Ruth Erickson, Spheris Gallery's Hope Higbie, Keith Brown at SEABA, and Mark Waskow; the wonderful folks at Capital City Press, Brad, Kevin, Sandy, Dave, Steve, and Jody.

Ric would especially like to thank Barbara O'Brien at *Art New England* and Joe Healy at *Vermont Magazine* for the opportunities to write about art in Vermont over the past few years.

We would also like to express our deep appreciation to the artists, curators, gallerists, and other people who make up Vermont's art scene. Your commitment and desire to bring art into the world has brought joy into our lives. Keep it up.

INTRODUCTION

As most of us have done at one time or another, we found ourselves standing in a bookstore looking for a book that didn't exist. It was one of those, Wouldn't It Be Great If, moments. Specifically, Ric wanted a book that listed all the places to see art in Vermont.

As the Vermont Regional Reviews Editor of *Art New England*, Ric criss-crossed the state looking at art every month or two in order to choose the exhibitions he would recommend for a review in the magazine. Recently, he found himself going back to the same venues over and over, finding worthwhile exhibitions, but unable to resist the nagging suspicion he was missing something.

Not finding such a book on the shelves, Ric inquired with a member of the store staff.

"What a great idea," she said, declaring that she was the local book buyer and that she thought such a book should exist. Driving home her point, she added, "You should write it."

At the time, we laughed off the suggestion. After all, a book, and specifically a guide book, was a huge undertaking. We guessed there were over one hundred art venues, each with addresses, phone numbers, websites, and emails, each offering something just a little different from the next. Capturing all the information, plus the flavor of each venue seemed overwhelming.

As Ric continued traveling around the state, he floated the idea with gallery owners, curators, and artists. Upon finding a lot of support for the idea, he convinced Chris to join him in creating the *Vermont Art Guide*. Little did we know what we were getting into.

We traveled to more corners of the state than most people know exist. From the Canadian to the Massachusetts borders three times, from Lake Champlain and Upstate New York to the Connecticut River another three times. We drove all of Routes 7, 100, 4, 9, and 5, much of Routes 108, 30, 22A, 15, and 14. We even drove the entire length of "Route 66," a three mile stretch of town road between Maple and Green Streets south of Vergennes and Route 66, the state highway that runs between Randolph and East Randolph. We visited almost all of the nearly 300 venues in the book, stopping for an hour or so in some places, darting in and out in less than five minutes at others.

Here are some things we found:

Contemporary visual arts are thriving in Vermont. Art is exhibited in every corner of the state, in traditional galleries and adapted or alternative venues. The walls are dripping with work.

What makes an 'art venue' is as diverse as the work being exhibited. Not all community organizations present curated or juried work, through some employ curators or conduct extensive jurying processes. Sometimes membership is open, sometimes membership is dependent on passing rigor with fellow artists. Restaurants and other commercial, retail establishments tend to make themselves available, but some establish a relationship with a particular curator or artist who oversees exhibitions. All of this impacts the quality of work on view and the consistency of that quality.

Artists and other members of the arts community are adapting barns, banks, old mansions, firehouses, churches, factories and any other sort of space they are able to get their hands on. There is not enough room in these pages to explore this topic completely. Artists have always adapted space to suit their needs. Particular to Vermont is the number of landmark buildings that have become art centers. Firehouses in Burlington and Hardwick, a bank in Springfield, and countless barns are now in service of artists and the communities they

create. As such, many art venues in Vermont hold prominent locations in their towns and cities. What effect this has on the role of art in the community, or the perception of the role, deserves further exploration.

Which brings us to another point. Across the state, art is serving as a form of economic development and community organizing. Brandon, Bellows Falls, White River Junction, and Burlington's South End are all seeing renaissances in part due to creative economic development. Artists are rehabilitating buildings and entire downtowns, often without government support. The desire to make art seems to go hand in hand with the desire to make livable, viable communities. "Creative economy" is the new catch phrase in economic development. Vermont provides a number of examples where talk has been put into action. Community leaders should take note.

This book makes no effort to rate or judge the art venues listed. However, our research has led us to have some observations about what makes a good art venue. The better art venues, no matter what sort of space they occupy, have a clearly identified curator or coordinator. Sometimes, this responsibility is shared by a guild or group of artists, other times, a professional gallerist works for or partners with the venue.

The better venues publicize the exhibitions, print gallery cards, work to get media attention, put up a website, purchased advertisements in newspapers, or distribute information about the artist and the work on view. In short, they take themselves seriously, make a commitment, and follow-through. We applaud these hard working folks. Not only do they make art more accessible, they further the larger cause of art.

Art is important. Economically, art is a low-impact industry with strong community connections. Art makes you think. Whether you are pondering the symbolism and deeper meaning of a work, or simply trying to understand how an artist layered paint to created an image, art massages your brain and you are a better person for it. Art is the original spiritual food. It allows us to experience feelings and states of being that cannot be communicated by mere words. Something so powerful deserves our respect and when it moves us, our admiration.

One of the reasons we decided to create this book, aside from the fact nothing like it existed, is to support art in Vermont. We hope that you, the reader, will use it to seek out new venues and participate more in Vermont's vibrant art scene. Join in a gallery walk, attend an art opening, buy art, support arts organizations, visit an artist's studio. Art cannot exist in a vacuum; it needs you as much as you need it.

Here are some things you may need to know about this book in order for it to be more useful to you:

Whenever possible, we included the hours during which the venue was open. Many venues listed in this guide are staffed by volunteers or working artists whose relationship with time is flexible. Venues often close to prepare for installations and change their business hours to meet seasonal demands. Readers are encouraged to contact a venue directly in order to see if the venue is indeed open at the time they intend to visit.

We received no compensation from venues for inclusion in this guide and listings were entirely at our discretion. We made every effort to include all venues that exhibit contemporary visual art and some venues that exhibited collections significant to the community. We recognize that 'art' and 'contemporary' have different meaning for different people. We draw a distinction between visual art, which is a material thing that expresses ideas, thoughts, and feelings from a craft which is a material thing that incorporates function, form, and design within a particular medium.

We also draw a distinction between painting, print, and photography which function as a medium, meaning visual art which uses techniques to *reproduce* ideas, thoughts, and feelings and painting, print, and photography which function as art, meaning the medium serves a larger purpose of *expressing* ideas, thoughts, and feelings.

Contemporary refers to the art of now. This means work by living, working artists who are selling or presenting work to art consumers and viewers.

We recognize these distinctions are debatable and possibly contentious. Our intention is not to cause debate but to create a useful, meaningful guide for art consumers and viewers. We welcome dialogue on these issues.

A venue may not be included for any number of reasons set out above as well as simple oversight. Exclusion in the *Vermont Art Guide* cannot be assumed to be comment or statement on the quality, mission, or work of the venue.

A note about zip codes and maps: Each venue has its zip code listed. This is to help guide users find venues when using on-line map programs such as Mapquest or Rand-McNally. A map is always good to have when traveling around Vermont-the more detailed the better. When researching the venues, the authors relied on Northern Cartographic's *Vermont Road Atlas & Guide*, a valuable tool for those who plan to seek out many of the more rural venues.

Throughout the book, you will find listings of artist studios. This is by no means a comprehensive list, but rather a collection of artists who at one point or another have come to our attention. More often than not, it is necessary to call ahead and make an appointment. Some artists keep regular hours and their studios are attached to galleries.

Visiting an artist's studio can be a wonderful experience. Not only will you become intimately familiar with an artist's work and process, you will have the opportunity to learn first hand what their work is about. Artists have different approaches to studio visits. Some have a well-thought out tour and speech about what they do, while others simply make themselves available to answer questions and show their work. Some artists will sell their work directly from their studio, others may refer you to a gallery that represents them. Most artists are open to discussing commissioned work.

In conclusion, we hope you find this book a useful tool for seeking out art in Vermont. We hope that you will use the listings to plan day trips, attend openings, or contact artists. Please feel free to share your experience with us using the contact information found after the index.

The one message we got over and over when writing and researching this book is this: Vermont Art is Good. We hope you discover how good it is.

NORTHWEST VERMONT

The Islands ♦ St. Albans ♦ Chittenden North
Chittenden South ♦ Shelburne

From the Canadian Border and along Lake Champlain, Northwest Vermont includes a number of distinct regions: Franklin County, The Islands of Lake Champlain, and Chittenden County for which we distinguish those art venues north of Interstate 89 from those venues to the south, including Shelburne. The art scene in Northwest Vermont is dominated by Burlington which we have included in a separate chapter.

The Lake Champlain Islands, including the towns of Alburg, North and South Hero, and Isle La Motte, have benefited greatly from the work of the volunteer-run Island Arts. Island Arts supports arts and cultural activities including exhibitions of visual art. St. Albans is the largest town in Franklin County and the home of that community's few art venues.

Moving South on Route 7 (or Interstate 89 if you're in a hurry) one finds a number of art venues in Chittenden County outside of the Burlington core. Enigma Gallery, housed in an outlet mall, is the up and coming arts out-post in Essex Junction. Further out on Route 15, one finds the Art Gallery at the Old Red Mill, a collective community effort, and Emile A. Gruppé Gallery, a gem tucked off on a side road and behind a farm house. Visitors will be rewarded for seeking this venue out.

South of Interstate 89, just outside of Burlington, one finds a number of professional, for-profit galleries: Blue Heron Gallery in South Burlington and Furchgott Sourdiffe Gallery in Shelburne. Also in Shelburne, the Gallery on the Green consistently has excellent exhibits and the Shelburne Museum is a treasure trove of Americana.

The Islands

Four Winds Studio

Route 2 (1/4 mile south of Shore Acres)
North Hero 05474
(802) 318-8958
The Studio is open daily during the Summer and Fall.

Oils and watercolors, marble sculpture, stained glass, and an assortment of other work can be found in this North Hero store that has hosted stone carving demonstrations in the past.

ART AND FOOD

Blue Paddle Bistro

316 Route 2
South Hero 05486
(802) 372-4814

This popular restaurant has an upstairs gallery which shows art by regional artists.

Fisk Farm

3849 West Shore Road
Isle La Motte 05463
(802) 928-3364
www.fiskfarm.com

This site overlooking Lake Champlain, contains a bed and breakfast, opportunities for small retreats, a tea garden, and, in summer, art and craft shows in the barn.

Island Arts

www.islandarts.org

The goals of Island Arts are to provide a showcase for local artists, performers and crafters; encourage local students in artistic achievement; and bring professional high-quality talent to the Islands, while helping to integrate the arts into community life. While not a physical venue, Island Arts presents a rich and varied program of activities throughout the region including the exhibition of art at a number of venues. Organized by volunteers, the venues include welcome centers and banks. Each venue primarily shows rotating exhibits of local artists. Artwork is for sale. It's best to check their website for current information.

Chittenden Bank

3 South Main Street (Route 2)
Alburg 05440
(802) 796-3411

The bank is open Monday through Thursday from 8:30 a.m. to 3 p.m. and Friday from 8:30 a.m. to 5 p.m.

Vermont Welcome Center

Route 2 West
Alburg 05440

Lake Champlain Islands Chamber of Commerce

3501 Route 2
North Hero 05474
(802) 372-8400
www.champlainislands.com

The Chamber offices are open Monday through Friday from 8 a.m. to 4 p.m. Between Memorial Day and Labor Day, the offices are open Monday through Friday from 8 a.m. to 5 p.m. and Saturday and Sunday from 10 a.m. to 2 p.m.

Merchant's Bank

301 Route 2
South Hero 05486
(802) 372-4222

The bank is open Monday through Thursday from 9 a.m. to 4 p.m. and Friday from 9 a.m. to 5:30 p.m. Art is shown in the conference room.

St. Albans

Blue Eyed Dog

54 North Main Street (Route 7), Upstairs
St. Albans 05478
(802) 524-4447
Open Tuesday through Saturday; Summer hours are 10:30 a.m. to 4 p.m.;
Winter hours are 10:00 a.m. to 5 p.m.

Jack Welch shows his own work plus art by over a dozen other artists in this second floor gallery on Main Street in St. Albans. On view is work by acrylic painter Tess Beemer, small landscapes by Corliss Blakely; watercolors by Eric Bataille; and other painters and photographers. The gallery has three rooms and a frame shop.

Champlain Collection, Ltd.

Highgate Commons Shopping Center
223 Swanton Road (Route 7)
St. Albans 05478
(802) 524-3485
www.champlaincollection.com
The store is open Monday through Friday from 9:30 a.m. to 5:30 p.m. and on Saturday from 9:30 a.m. to 5 p.m. Closed on Sunday.

This principally home décor store has an extensive collection of work by painter Fred Swan. Champlain Collection publishes art prints including giclees on canvas and paper. They also publish Civil War prints and offer custom framing.

ART AND FOOD

Jeff's Maine Seafood

65 North Main Street (Route 7)
St. Albans 05478
(802) 524-6135

This St. Albans seafood restaurant has exhibitions by local artists.

Chittenden North

Enigma Gallery

At Essex Shoppes and Cinema (exit 10, Route 289)
21 Essex Way, Suite 101
Essex 05451
(802) 879-9220
www.viewenigma.com
The Gallery is open Tuesday through Saturday from 11 a.m. to 7 p.m. and
Sunday 11 a.m. to 5 p.m. Closed Monday.

"While art is subjective, Enigma's role is to present a diverse range of images
and objects for the viewer to observe, contemplate and explore. The result
being a better understanding of the creative process and the impact of living
an artful life."

Located in the Essex Outlet Mall, the Enigma Gallery offers fine and func-
tional art. Pamela Eaton Siers, formerly of Frog Hollow Arts Center, brings her
eye for SOFA (Sculpture Objects & Functional Art) to this 4200-square-foot
space. Enigma opened in November 2004. Regularly issuing national calls
to artists, Enigma produces well thought-out exhibitions every month or two
months. An exhibition calendar is posted on their website. Their regular stock
of artists includes Alistair McCallum, Janet Van Fleet, Kathy Stark, Doug
Pfliger, and a few dozen others.

Lorraine C. Manley

36 Manley Road
Milton 05468
(802) 893-7860
By appointment.

From the artist: "The natural beauty of my native Vermont has been perhaps
the greatest influence on my art. I enjoy painting views of the landscape in
very vivid, lush colors, many times much more intense than seen in nature. I
use the palette knife and brush energetically for a more spontaneous result. I
try to capitalize on the special 'accidents' and properties of the oils or acrylics
to come up with an exciting, textural, impressionistic and often abstracted
painting of nature's shapes and seasons. This exuberant, painterly style excites
me."

Leslie Fry Sculpture

48 Elm Street
Winooski 05404
(802) 655-4349
www.lesliefry.com
By Appointment.

Leslie Fry makes engaging sculpture from a variety of materials: fabric, bronze, concrete, to name a few. Her subject is the intersection of natural and human worlds, reality and fantasy. Grecian columns, fallen Roman temples, gnome-like creatures, sphinxes, and ziggurats are just some of the imagery found in her work. The results are mythological, biological, and creations deeply rooted in a dreamy humanity. Leslie receives visitors at her studio in Winooski by appointment. Her website contains a broad selection of her work. A public art installation can be seen at Pomerleau Neighborhood Park at Shelburne Road Plaza (Price Chopper) in Burlington.

Art Gallery at the Old Red Mill

Vermont Route 15, by the River Bridge
Jericho 05465
(802) 899-3225
The Gallery is open April through December, Monday through Saturday from 10 a.m. to 5 p.m. and on Sunday from 1 to 5 p.m. January through March, Wednesday and Saturday from 10 a.m. to 5 p.m. and on Sunday from 1 to 5 p.m.

Poised majestically over a gorge in the Brown River, Old Red Mill is a National Historic Site and home to an art gallery, craft shop, and museum.

On the main floor of the Mill, a gallery provides space for local artists. New exhibits are hung monthly. The volunteer-run craft shop features work by local crafters and snowflake-themed items.

A large section of the mill is dedicated to The "Snowflake" Bentley Exhibit. At age 19, William A. Bentley (1865-1931) pioneered photomicrography, which allowed him to capture the image of a single snowflake. He went on to photograph over 5,000 of them, never finding two the same. On view are memorabilia and some original works by Bentley. Reproductions of the photographs are also for sale.

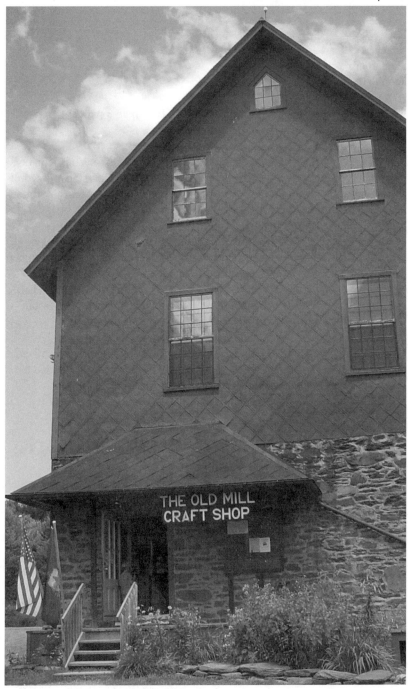

Art Gallery at The Old Red Mill in Jericho.

Emile A. Gruppé Gallery

22 Barber Farm Road
Jericho 05465
(802) 899-3211
The gallery is open Thursday through Sunday, 10 a.m. to 3 p.m. or by appointment.

The daughter of American Master Emile Gruppé owns and runs this remarkable gallery that bears his name. Located in a converted barn in the rolling hills of Jericho, visitors will find impressionistic landscapes and portraits by Emile Gruppé as well as contemporary artists whose work compliments his.

Emile Gruppé (1896-1978) was the son of landscape artist Charles Gruppe (1860-1940). After traveling and studying in Europe, Emile created a Summer School in Gloucester, Massachusetts in 1941. He traveled regularly to Vermont, visiting the Smuggler's Notch Inn which had a studio in the back that was available to artists when the weather was less that obliging. As a result, Gruppé is well known for his Vermont landscapes.

Gruppé's daughter, Emilie, presents rotating exhibition as well as her father's and grandfather's work. The gallery is located in a converted barn behind the main farmhouse. The dogs are friendly.

Cat Spa Art Gallery and Cardworks

1797 Vermont Route 128
Westford 05494
(802) 872-1868
The Gallery is open Monday through Saturday from 10 a.m. to 5 p.m. and "maybe" on Sunday.

An old barn off Route 128 shows the bright, colorful work of Nancy Winters: brilliant florals, detailed old churches, landscapes, animals, and livestock. Cat Spa sits on a beautiful piece of land with great views of the mountains. In addition to Nancy's original work, a nice selection of greeting cards is for sale.

ART AND FOOD

Starbucks Maple Tree Place
10 Hawthorne Street (accessible from Route 2A)
Williston 05495
(802) 878-7360

This particular Starbucks has rotating exhibitions of local artists.

Chittenden South

Blue Heron Gallery

100 Dorset Street
South Burlington 05403
(802) 863-1866
www.blueheronartgallery.com
The Gallery is open Tuesday, Wednesday, Thursday, and Saturday from 10 a.m. to 6 p.m.; Friday from 10 a.m. to 7 p.m.; Sunday from 12 noon to 4 p.m. Closed Monday.

Located in the shopping complex next to Barnes & Noble, the Blue Heron Gallery offers a large selection of work by local artists. Connie and Ron Lavallee have been selling art for over twenty years and their experience comes through in this gallery and frame shop.

On view is a work in a range of media, including oil, acrylic, watercolor, sculpture, woodblock and etching. Of particular note are Sabra Field prints, including some of her earlier work; Julie Y. Baker Albright's luscious oil still lifes; and Sue Sweterlitsch's rustic watercolors.

Sean Dye Studio

681 Willow Brook Lane
St. George 05495
(802) 482-6421
www.seandyestudio.com
By appointment.

Sean Dye built a gallery and studio space next to his family's home in St. George to showcase his oil and pastel paintings. A graduate of the Pratt Institute, Dye has been recognized by the Sierra Pastel Society and the United Pastelists of America. He is a member of the Degas Pastel Society and The United Pastelists of America. His work is in numerous private and corporate collections. He teaches workshops across North America and lectures at the University of Vermont.

Dye's paintings are brilliant examples of how well pastels can be used to evoke natural beauty. Artists will particularly appreciate his mastery of water-soluble oils, a wonderful, but underused media.

The Birds of Vermont Museum

900 Sherman Hollow Road
Huntington 05462
(802) 434-2167
www.birdsofvermont.org
The Museum is open daily May through October from 10 a.m. to 4 p.m. Open in winter by appointment. There is an admission fee.

A retirement project of naturalist and master wood-carver Bob Spears, the Birds of Vermont Museum presents 120 free-standing exhibitions of wood-carved birds in their natural habitat. While the purpose of the Birds of Vermont Museum is primarily to teach visitors about birds and their role in the ecosystem, the Museum is also a testament to the underappreciated art of woodcarving.

The self-taught Spears began carving birds in 1938 at age 18. The collection in the museum shows the evolution of his technique and the application of fine detail to each work. Exhibits also contain other sculptural detail like aluminum dandelions and life-sized flies as well as color murals.

Also on view are Russell Hansen's photographs of birds in flight and artist Libby Davidson's hand-colored illustrations. The Museum presents an annual art contest for children who have attended the museum. The museum is next to the 255-acre Green Mountain Audubon Center, which has five miles of trails through hardwood forests, hemlock swamps, and the Huntington River.

Daryl V. Storrs

235 Bridge Street
Huntington 05462
(802) 434-5040
www.darylstorrs.com
By appointment.

Daryl sells hand-painted lithographs, original pastels, and jewelry with rural and agricultural scenes and a bright, festive palette. She has over 25 years of printmaking experience and has worked with the likes of David Bumbeck, and Sabra Field, and spent six weeks at the prestigious MacDowell Colony. Her studio is open by appointment.

Shelburne

Gallery on the Green
Shelburne Craft School

54 Falls Road (accessible from Route 7)
Shelburne 05482
(802) 985-3648 - fax (802) 985-8438
www.shelburnecraftschool.org/gallery.html
The Gallery is open Monday through Friday from 10 a.m. to 5 p.m. and on
Saturday from 11 a.m. to 5 p.m.

The Shelburne Craft School was founded in the early 1940s by Reverend J.
Lynwood Smith who believed that crafts were a vital part of culture. Initially,
young boys were taught woodworking in the church rectory. The program
expanded and the Shelburne Craft School was incorporated in 1945. Today it
continues to provide space to professional artists (see Random Orbit listing on
page 26) while teaching art and craft to members of the community.

At Gallery on the Green, visitors discover a beautiful and integrated visual
presentation of contemporary work, both decorative and functional, including
paintings, prints, photography, and fine crafts in many mediums created by
artists from Vermont and the United States. Solo and group exhibitions are
scheduled throughout the year.

In addition to the Gallery on the Green, the Shelburne Craft School has studios
on Harbor Road where classes take place.

Shelburne Museum

5555 Shelburne Road (Route 7)
Shelburne 05482
(802) 985-3346
www.shelburnemuseum.org
The Museum is open May through October from 10 a.m. to 5 p.m. An admission fee is charged.

Shelburne Museum is a Chittenden County landmark. The unique museum includes over 150,000 objects, some exquisite, some mundane, and some entire buildings, churches, and even a steamship. While not explicitly an art museum, the museum has a remarkable collection of art.

The Museum's Impressionist collection includes work by Claude Monet, Edouard Manet, Edgar Degas, Mary Cassatt, and work by pre-Impressionist painters Gustave Courbet, Jean-Baptiste-Camille Corot, and Charles-Francois Daubigny. The work is shown in a 1930's Park Avenue apartment that lives in a building at the museum.

The collection of 19th-century American paintings include work by Thomas Cole, John Kensett, Albert Bierstadt, Martin Johnson Heade, Fitz Hugh Lane, John Singleton Copley, William Merritt Chase, John Peto, Winslow Homer, Eastman Johnson, and John Quidor. Twentieth-century paintings include work by Carl Rungius, Andrew Wyeth, and Ogden Pleissner. This work can be found in the Pleissner and Webb Galleries.

Lastly, the museum has an extensive collection of folk art by unnamed and named artists like Grandma Moses, Edward Hicks, William Matthew Prior, Erastus Salisbury Field, Joseph Whiting Stock and Ammi Phillips. Some of this work is exhibited in The Collector's House, which the museum describes as "an inventive work of contemporary architecture that imagines the home of a 21st-century folk art collector."

Furchgott Sourdiffe Gallery
86 Falls Road
Shelburne 05482
(802) 985-3848
www.fsgallery.com
The Gallery is open Tuesday through Friday from 9:30 a.m. to 5:30 p.m. and on Saturday from 10 a.m. to 4 p.m.

Furchgott Sourdiffe Gallery is Chittenden County's oldest established gallery of contemporary fine arts and crafts. Presenting a stylistically diverse collection of original work, including oils, pastels, watercolors, and prints by artists of regional and national stature. The gallery also has a unique collection of fine crafts and gift items. Located in the relaxed setting of a Queen Anne Victorian building in Shelburne Village, Furchgott Sourdiffe Gallery also specializes in museum quality custom framing, and art and frame restoration.

Random Orbit
54 Falls Road (at the Gallery on the Green)
Shelburne 05482
(802) 985-3082
www.randomorbitstudio.com
By appointment.

Random Orbit is the design studio of Douglas Jones and Kim Kulow-Jones located at the Gallery On the Green. Doug is the woodworking resident at the Shelburne Craft School, where he directs the wood program. Kim is a visual artist trained at the Cleveland Institute of Art and apprenticed in Denmark. They both have Master's Degrees in Furniture Design from the Rhode Island School of Design. These highly trained artists often create sculptural, functional objects evocative of folk art. They sometimes use found or reusable objects-a tobacco container or old vegetable shortening can-to create refined and elegant objects. They use a wide variety of wood and take full advantage of how materials interact. The studio is open by appointment.

Jan Cannon Pottery

19 Garen Road
Charlotte 05445
(802) 425-6230
www.jancannonpottery.com
By appointment.

"I am fascinated by the processes of pottery and the possibilities of making the most basic elements of life-earth, water, fire, air and ether-eloquent. Minerals made plastic by water and shaped by a human hand, hardened by air and fire, ultimately emerging as a form that exists in and at times contains space; that the most basic elements of creation can affect a transcendental experience is truly magical."

Jan Cannon's work can be seen at her studio in Charlotte by appointment.

Marian Willmott Monoprints

1617 Hayden Hill West
Hinesburg 05461
(802) 482-3131
By appointment.

Monoprints are one-of-a-kind prints; essentially paintings that are printed and are, therefore, unique. Monoprinting is the simplest form of printing, but the art form is by no means easy.

Marian Willmott creates intense monoprints that employ ghosts and multiple layers that give the work depth and texture. She works with a variety of techniques: intaglio, stencil, collagraph and paper lithography.

Events in Northwest Vermont

APRIL
Vermont Maple Festival, St. Albans
Downtown St. Albans (Route 7)
(802) 524-5800
www.vtmaplefestival.org
Always held the last full weekend of April, the Vermont Maple Festival celebrates Vermont's most famous export. There is a parade, maple sugaring demonstrations and an antique show. The All Arts Council of Franklin County holds a Fine Arts Show, including painting, sculpture, photography, original music, and hand painted wooden boxes by Franklin County artists.

MAY
Vermont Craft Workers Essex Spring Craft and Fine Arts Show, Essex Junction
Champlain Valley Exposition, Route 15
(802) 878-4786 or (802) 879-6837
www.vtcrafts.com
Sponsored by the Vermont Craft Workers, this annual show brings together over 200 artists and craftspeople the weekend before Mother's Day. An admission fee is charged, but re-entry is allowed over all three days. Demonstrations, live entertainment and a variety of food vendors are also on hand.

SEPTEMBER-OCTOBER
Shelburne Farms Art Exhibition and Sale, Shelburne
Shelburne Farms Coach Barn, 1611 Harbor Road
(802) 985-8686
www.shelburnefarms.org
This annual event turned 18 in 2005. The exhibition and sale is a fundraiser for the programs of Shelburne Farms, a membership-based, non-profit and National Historic Site dedicated to cultivating an ethic of conservation. Works on display are from over 40 regional artists in a variety of media. An admission fee is charged. Tickets are available at the Shelburne Farms Welcome Center.

OCTOBER
Vermont Craft Workers Essex Fall Craft and Fine Arts Show, Essex Junction
Champlain Valley Exposition, Route 15
(802) 878-4786 or (802) 879-6837
www.vtcrafts.com
Celebrating its 25th year in 2005, this show, sponsored by the Vermont Craft Workers, is held the last weekend in October. Over 400 artists and crafts people are represented. An admission fee is charged, but re-entry is allowed over all three days. Demonstrations, live entertainment and a variety of food vendors are also on hand.

NOVEMBER
Artisan and Art Holiday Market, Jericho Center
Community Center, Browns Trace Road
(802) 434-2352 or (802) 899-4993
Held on a weekend before Thanksgiving, the annual Holiday Market offers quality work from area artists.

NOVEMBER
Vermont Hand Crafters Annual Holiday Craft and Fine Art Show, South Burlington
Sheraton Conference Center, 870 Williston Road
(802) 933-2420 or (800) 373-5429
www.vermonthandcrafters.com
This show has been held for over 50 years just before Thanksgiving and is presented by Vermont's oldest and largest juried craft organization. Fine art, photography, metal and decorative painting are included among the media represented. An admission fee is charged.

BURLINGTON

Downtown ♦ Church Street ♦ Burlington City Arts
Waterfront ♦ South End ♦ University of Vermont

The largest city in Vermont, Burlington has the greatest concentration of art galleries, artist studios, organizations, and events in the state. Historically the economic capital of the state, the city has well-developed industrial, retail, and residential districts.

Burlington is home to University of Vermont, Champlain College, and the Burlington Branch of the Community College of Vermont. The concentration of these institutions translates to an art scene full of youthful exuberance and energy. The city is decidedly progressive and has a long history of supporting the arts.

In spite of its commitment to the arts, Burlington has only one professional, for-profit gallery, Doll-Anstadt Gallery. Art venues are often community efforts. Burlington City Arts dominates the art scene providing both studio facilities and exhibition space. A number of years ago, a group of artists turned an old bread factory into the Rose Street Artists' Coop, a residential and working space for artists. In recent years, Burlington's South End has seen a revitalization with the advent of the South End Arts and Business Association, which produces the annual Art Hop, the state's largest arts event.

In the heart of the city, the Church Street Marketplace is an outdoor pedestrian mall that stretches from Main to Pearl Streets and runs parallel to the Waterfront. Lots of shops and cafés make Church Street a great place to hang out and meet up with folks. Church Street also makes up the core of Burlington's monthly art walk (see the Events section at the end of this chapter).

As the Church Street Marketplace has grown and developed over the years, fewer and fewer art galleries exist on the actual pedestrian mall. Fortunately, many are just a hop, skip, or jump away in the Downtown area.

Burlington's Waterfront is a natural treasure. Formerly rail yards, the city has worked hard over the years to develop the area as a center for recreation. The bike path which runs along the shore of Lake Champlain attracts many visitors. Retail and art spaces are beginning to pop up in the area.

The vibracy of Burlington's art scene is in large part due to the alternative weekly newspaper, *Seven Days*, which reviews exhibitions and publishes extensive arts listings. Anyone wanting to know what's happening in the art world during any given week should pick up a copy of this paper which is available at many locations around town and in Northern and Central Vermont.

Downtown

Doll-Anstadt Gallery

87 College Street
Burlington 05401
(802) 864-3661
www.dollanstadtgallery.com
The Gallery is open Wednesday through Sunday from 11 a.m. to 5:30 p.m.
or by appointment.

Founded by Stephen Doll and Jay Anstadt, the Doll-Anstadt Gallery has developed an outstanding reputation for showing a diverse selection of New England artists. Monthly exhibitions highlight a specific artist. With an emphasis on landscapes, Doll-Anstadt regularly shows work by Gail Salzman, Henry Isaacs, and Peter Arvidson. With recent exhibits by Ethan Murrow and Kasy Prendergast, Gallery Director Stephen Doll has demonstrated a knack for spotting up-and-comers on the verge of making it big. Other artists include Beth Pearson, William M. Crosby, and Susan Fenton.

Amy E. Tarrant Gallery

Flynn Center for the Performing Arts
153 Main Street
Burlington 05401
(802) 652-4500 - fax (802) 863-8788
www.flynncenter.org/events/gallery.html
The Gallery is open to the public on Saturdays from 11 a.m. to 4 p.m. and prior to performances and during intermission for theatergoers.

The Amy E. Tarrant Gallery at the Flynn Center for the Performing Arts is an extension of the lobby and provides a professionally lit and public gallery space. The Flynn operates the gallery as an enhancement to and extension of its performing arts programming, seeking to curate exhibitions of works by regional artists that have some relationship to Flynn programming during the time period of the exhibit. The relationship may be thematic, geographical, stylistic, or historical. There is no particular constraint other than the desire to present quality work that provides an interesting context for or dialogue with a particular performance, art form, performing arts process, or Flynn activity.

Fletcher Free Library

235 College Street
Burlington 05401
(802) 863-3403
www.fletcherfree.org
The Library is open Monday, Tuesday, Thursday and Friday from 8:30 a.m. to
6 p.m.; on Wednesday from 8:30 a.m. to 9 p.m.; on Saturday from 9 a.m. to
5:30 p.m.; and on Sunday from 12 noon to 6 p.m.

Burlington's Fletcher Free Library has been a point of civic pride on the corner
of College Street and South Winooski Avenue since it opened, thanks to the
generosity of Andrew Carnegie, in 1904. While it was almost demolished in
the mid-Seventies because of structural damage it received in 1974, the build-
ing remains today because of the vigilance and commitment of Burlington
citizens who saw to the restoration of and addition to the magnificent structure.
The library has an active exhibition program. Many of the artists are from
Vermont, but some are from Massachusetts and New York. Many are in the
beginning of their career who are looking for exposure of their work.

Grannis Gallery

170 Bank Street
Burlington 05401
(802) 660-2032
www.grannisgallery.com
The Gallery is open Monday through Saturday from 10 a.m. to 6 p.m., Friday
from 10 a.m. to 8 p.m., Sunday from noon to 8 p.m.

Grannis Gallery showcases jewelry, art and sculpture in its location just off of
Church Street. The gallery shows handmade jewelry from over 40 designers
and goldsmiths. The gallery presents bi-monthly shows of work by Vermont
visual artists, often in conjunction with a featured jewelry artist, designer or
goldsmith. Recent shows have included work by photographer John Church-
man; painters Gebo Church, Linda Jones, and Carol Boucher; jewelry artist
Lee Angelo Marraccini; and goldsmiths Richard Messina, Jacob Snow and
Gabriel Ofiesh. In addition, the gallery shows metalwork by Timothy Grannis,
who owns the gallery with his wife, Linda Hurd. Grannis, who studied with
master Finnish goldsmith Heikki Seppa, presents his own jewelry and metal
sculpture in the gallery. Grannis was an award winner in the 2002 Saul Bell
Design Competition. Hurd has traveled widely performing guitar in a number
of string bands, as well as working for art-to-wear clothing designer Lynn
Yarrington. Grannis Gallery is the realization of her heart's dream to promote
art and artists.

Community College of Vermont
Hallway Galleries
119 Pearl Street
Burlington 05401
(802) 865-4422
www.ccv.edu/locations/burlington/hallway_galleries/index.html

The Burlington branch of Community College of Vermont, CCV for short,
invites artists to exhibit their work in the hallways of their complex on Pearl
Street. The galleries are in the main hallway in the Pearl Street building, the
atrium near the Cherry Street entrance, and on the third floor of the Cherry
Street building. Art is displayed for a semester and CCV often hosts artist talks
or lectures which focus on artistic process, use of materials, and design.

Cathedral Church of Saint Paul
2 Cherry Street
Burlington 05401
(802) 864-0471 - fax (802) 860-0489
www.CathedralArts.org

The outside of the Cathedral features a large crucifix created in 1951 by
Charles Unlaf. The Cathedral has an artist-in-residence program and has
regular exhibitions, which are announced in *Seven Days*.

ART AND FOOD

Muddy Waters
184 Main Street
Burlington 05401
(802) 658-0466

The quintessential coffeehouse, Muddy Waters shows work by local artists:
paintings, photography, collage.

Daily Planet
15 Center Street
Burlington 05401
(802) 862-9637

Daily Planet has a well-organized exhibition program. Notices of who is
showing can regularly be found in *Seven Days*.

Radio Bean

8 North Winooski Avenue
Burlington 05401
(802) 660-9346
www.radiobean.com

Burlington's bohemian enclave, Radio Bean offers a unique, eclectic mix of art, music, and coffee: funkiness at its best. One block from Church Street (east up Pearl Street, go left onto North Winooski), the café feels more like a living room that spills out on the street. Plants, funky lamps on tables, and a small stage fill the space. Art hangs on brick walls.

Penny Cluse Café

169 Cherry Street
Burlington 05401
(802) 651-8834

Local artists put their work in this very busy breakfast spot.

The Wine Bar at Wine Works

133 St. Paul Street
Burlington 05401
(802) 951-9463
www.wineworks.net

Comfy wine bar with art on the walls, Wine Works is a great place to meet-up with friends and sip some merlot.

ART AND MONEY

Chittenden Bank-Burlington Square

2 Burlington Square
Burlington 05401
(802) 658-4000
www.chittenden.com
The branch is open Monday through Thursday from 8 a.m. to 5 p.m. and Friday from 8 a.m. to 6 p.m.

This branch of the Chittenden Bank has exhibits of local artists.

Church Street

Ice Coast Gallery

113 Church Street, 3rd Floor
Burlington 05401
(802) 865-5210
www.icecoastgallery.com
The Gallery is open Friday and Saturday from 10 a.m. to 6 p.m.; on Sunday
from 12 noon to 5 p.m.; and other times by appointment

Two stories above Leunigs Bistro is Ice Coast Gallery, a venue dedicated to
showcasing fine art and craft by emerging and established artists working in
all media. Exhibits change monthly or bimonthly. Ice Coast Gallery is also the
home of Tabbatha Henry's ceramic studio.

Frog Hollow Vermont State Craft Center

85 Church Street
Burlington 05401
(802) 863-6458
www.froghollow.org
The Center is open Monday through Wednesday from 10 a.m. to 6 p.m.;
Thursday through Saturday from 10 a.m. to 8 p.m.; and Sunday from 12 noon
to 6 p.m.

Frog Hollow Burlington is a contemporary craft gallery with sometimes fine
art exhibited in the back gallery. See Frog Hollow Vermont State Craft Center
on Page 63 for a more complete discussion.

dug Nap Studio
184 Church Street
Burlington 05401
(802) 860-1386
www.dugnap.com
The Studio is open by appointment.

Two blocks from the Church Street Marketplace, the entrance to dug Nap's
studio is through the bulkhead entrance behind the building. Working with
oils on birch plywood, sometimes acrylics or gouache, Nap creates fun, witty
pieces of bears, cows, moose, dogs, raccoons, and people generally expressing
ironic sentiments. An image of two bears has the tag line, "As a matter of fact
we do go to the bathroom in the woods." On the surface folksy and fun, Nap
often presents biting social commentary. One image of a cow reads, "Vermont
is really boring, & that's why we like it." Nap sells original work as well as
cards and prints at a variety of locations around the state as well as the Frank J.
Miele Gallery in New York City.

ART AND HAIR

Art Space 150 at The Men's Room
150-B Church Street
Burlington 05401
(802) 864-2088
www.mensroomvt.com/artspace.html
The Men's Room is open Monday from 10 a.m. to 6 p.m.; Tuesday from 9 a.m.
to 6 p.m.; Wednesday and Thursday from 9 a.m. to 7 p.m.; Friday from 9 a.m.
to 6 p.m.; and Saturday from 8 a.m. to 5 p.m. Closed on Sunday.

Lots of commercial businesses exhibit art, but few do it as well as this venue.
A men's oriented hair salon, proprietor Glenn Sautter seamlessly combines
hair and art. Exhibitions focus on local artists and the venue has a dedicated
gallery space. Work is also shown throughout the salon. Exhibitions change
every other month or so. The work is eclectic and bold.

ART AND FOOD

Smokejack's Restaurant

156 Church Street
Burlington 05401
(802) 658-1119
www.smokejacks.com

Bold American cuisine using lots of local producers, Smokejack's has been a welcome edition to Church Street since it opened in 1997. The art it shows is equally bold.

Uncommon Grounds

42 Church Street
Burlington 05401
(802) 865-6227

Popular coffee-spot across from Old Navy shows work by area artists. Don't be shy about going in to check it out.

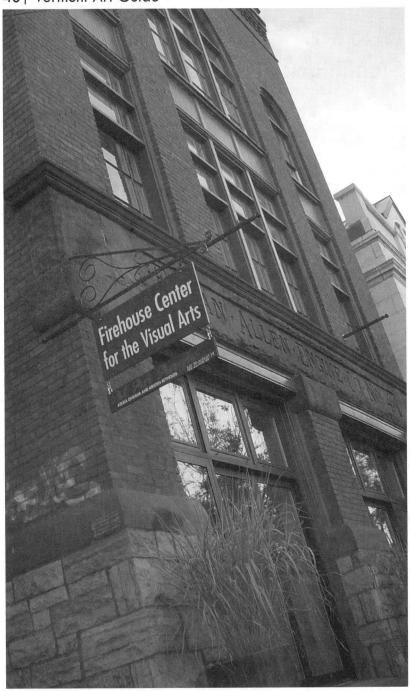

Firehouse Gallery on Church Street in Burlington.

Burlington City Arts

149 Church Street
Burlington, Vermont 05401
(802) 865-7166

Burlington is regularly touted as one of the most livable cities for the arts by groups like the U.S. Conference of Mayors. In 1981, then Burlington Mayor, now Congressman Bernie Sanders created the Mayor's Arts Council (MAC) whose mission was to make the arts available to all residents of the city. MAC organized festivals and concert series and created public exhibition spaces like the Metropolitan Gallery on the walls of City Hall. Two years later, MAC had a small budget, a part-time coordinator, and an office in a janitor's closet in the basement City Hall. MAC became Burlington City Arts (BCA) in 1990 and a full-fledged department of the city.

In 1995, BCA opened a temporary gallery space on the ground floor of the Ethan Allen Firehouse next to City Hall on Church Street. This venue quickly proved itself and almost immediately the idea of developing the Firehouse into an art center took shape. In 2002, a fully renovated Firehouse Gallery opened to the public. The rest of the building opened 2004.

Today, the mission of Burlington City Arts sums it up nicely, "to sustain and enhance the artistic life of the Greater Burlington Community." To this end, BCA has an impressive list of programs and exhibition spaces. The restored and renovated Ethan Allen Firehouse is now the Firehouse Center for the Visual Arts. In addition to a gallery, it also houses a community darkroom, education program, and artist-in-residence studio. From May to October, an artist market takes place behind the Firehouse Center in City Hall Park.

BCA offers dozens of classes to the general public, young people, and seniors. In the Memorial Auditorium building (250 Main Street), print and clay studios serve artists as well as people interested in learning more about these medium through experiencial workshops. Local writers particpate in writing classes and public readings.

The dynamic nature of Burlington City Arts is a testament to the enthusiasm and commitment the people of Burlington have for creativity and expression. At the organization's website (www.burlingtoncityarts.com), one will find classes, events, and exhibition information as well as information on volunteering, membership, and a much more indepth history of the organization and the Firehouse Center for the Arts than is presented here.

Firehouse Gallery

135 Church Street
Burlington 05401
(802) 865-7551
www.burlingtoncityarts.com/firehousegallery/
Call the gallery for seasonal hours.

The Firehouse Gallery presents contemporary art by local, regional, and national artists. For example, recent exhibitions have focused on work by Montreal painter Sylvie Safdie and the edgy-political, art-for-the-masses guy Max Schuman. Professionally curated, exhibitions are sometimes challenging and always engaging. Opening receptions bring out lots of local artists.

Metropolitan Gallery at City Hall

149 Church Street
Burlington 05401
(802) 865-7166
www.burlingtoncityarts.com/firehousegallery/metropolitangallery/

Up the stairs of City Hall on the walls of the main lobby, the Metropolitan Gallery shows juried work by artists from the Burlington area.

Art in Public Places

All around Burlington
(802) 865-7166
www.burlingtoncityarts.com/programs/artinpublicplaces/

The city of Burlington is a treasure trove of public art conveniently organized by Burlington City Arts in an attractive walking tour guidebook. Contact Burlington City Arts or stop in at the Firehouse Gallery to get a copy. The collection, if you will, includes a number of pieces by the late Paul Aschenbach, a sculptor and University of Vermont professor of art. On exhibit are examples of Aschenbach's welded metal pieces such as the playful Three Children at the First Congregational Church on Winooski Avenue and his stone work exemplified by Sculpture in the Community, a collaborative series he completed in 1974 with Bill Ford, Terry Dinan, John Watenberg, Bob Vesely and several of his students from UVM.

Airport Gallery
Burlington International Airport

1200 Airport Drive
South Burlington 05403
(802) 865-7554
www.burlingtoncityarts.com/firehousegallery/airportgallery/
The Airport is open daily from 9 a.m. to 12 midnight.

"Burlington International Airport has become such a culturally interesting place largely because the airport administration is so supportive of the art program out there, and they really understand what a difference it makes to travelers to get a sense of place--this isn't just like every other airport-- and how well art works to take the edge off of the anxiety of traveling," said Burlington City Arts' Sara Katz

Managed and curated by Burlington City Arts, the Airport Gallery at the Burlington International Airport isn't so much a gallery as it is an adaptation of the airport walls for the purposes of exhibiting art. Rotating exhibits can be seen in the Skyway Corridor and at Gates 1 & 2. In 2005, the airport unveiled "Skygates" a permanent installation by artist John Anderson in which he applied bold drawings on the inverted wells of four large skylights, each a different color field.

Waterfront

ArtPath Gallery
Wing Building
Burlington 05401
(802) 563-2273

The hallway of the Wing Building is ArtPath Gallery, but don't let that put you off. ArtPath is an excellent example of adapted space, something artists in Vermont are remarkably good at. A long corridor coordinated by Ellie Jacobson, the space is well lit with directional overhead lighting and Jacobson's selection of work tends to be strong and eclectic. Multiple artists are often on view. Shows rotate frequently.

Pursuit Gallery
1 Steele Street, Suite 125 (South End of the Wing Building)
Burlington 05401
(802) 862-3883
The Gallery is open Monday through Friday from 9 a.m. to 6 p.m.; Saturday from 11 a.m. to 6 p.m.; and Sunday from 10 a.m. to 4 p.m.

Pursuit Gallery is the collaboration of life-long friends Seth Neary and Skye Chalmers. The gallery features work from up-and-coming artists to renowned professionals in all media. Seth and Skye developed the gallery as a way to show off the range and excitement of creating artistic "pursuits that fuel people's passion for life and, in doing so, encourage others to follow their individual pursuits and dreams in all forms of art" including painting, photography, music, writing, sport, dance and more. Seth, a retired professional snowboarder, is a graphic designer and video producer. Skye is a photographer, whose work can be seen in the gallery, and a graphic image manager.

Art's Alive Gallery
1 Main Street (Union Station)
Burlington 05401
(802) 864-1557

Walk into the lobby of 1 Main Street, better known as Union Station, and find rotating exhibits of local artists. Art's Alive, the organization that produces the annual event, also maintains this gallery.

Union Station on the Waterfront in Burlington.

Montstream Studios

1 Main Street
Burlington 05401
(802) 862-8752
www.kmmstudio.com
The Studio is open Monday through Friday from 10 a.m. to 2 or 3 p.m.,
"but some days we don't come in." Closed on weekends, but they are at the
Burlington Farmers' Market most Saturdays from 9 a.m. to 2 p.m.

Along with the Art's Alive Gallery, Union Station is home to Katherine
Montstream's studio. Katherine has built a reputation for lovely landscapes
and other scenes of life in Burlington and along the shores of Lake Champlain.
She works in oil and watercolor and produces limited edition prints and
greeting cards.

North End

Studio STK

64 North Street
Burlington 05401
(802) 657-3333
The Studio's hours vary. Please call for an appointment.

Studio STK is the studio of Sage Tucker-Ketcham. The space is comprised of
seven rooms and a broad, u-shaped hallway. One room comprises the gallery
space, which includes works by Tucker-Ketcham and other artists. Additional
work lines the hallway. Tucker-Ketcham's plans for the rest of the space
include art classes for children and adults.

Rose Street Artists' Cooperative & Gallery

78 Rose Street
Burlington 05401
rosestreetgallery@hotmail.com
The Gallery is open by appointment.

Located in an old bread factory, the Rose Street Artists' Cooperative has
affordable living and studio space for local artists. The lobby is regularly
turned into an exhibition space, and a common area hosts coffeehouses and
performances.

South End

South End Arts and Business Association (SEABA)

180 Flynn Avenue
Burlington 05401
(802) 859-9222 - fax (802) 859-0222
www.seaba.com
The office is open Monday through Friday from 9 a.m. to 5 p.m.

From Pine Street, travel west on Flynn Avenue, cross the railroad tracks, and turn right. In an old industrial park, behind the Vermont Hardware Building, South End Arts and Business Association (SEABA) has a bright pink flamingo perched on its outdoor light. The nerve center of the area's creative economy, the non-profit organization is a blend of art, business, and industry. Members of the organization range from working artists and artisans to retail outlets or small manufacturers.

When not being exhibited elsewhere, the walls of SEABA are filled with its Folio Project, original works by twenty-two area artists. An edition of ten, the folio is for sale, a rare opportunity to own a vast collection of local work. At other times, SEABA has a rotating gallery of work by SEABA's members.

SEABA's annual event, the South End Art Hop brings thousands of visitors and presents the work of a few hundred artists in dozens of adapted gallery and studio spaces. The organization also hosts talks and other programs throughout the year. (See the Events section at the end of this chapter.)

47 Sanctuary Artsite

47 Maple Street
Burlington 05401
(802) 864-5884
www.47sanctuary.com
The Artsite is open Monday through Friday from 9 a.m. to 5 p.m.

Sanctuary Artsite is an independent, nonprofit gallery operated by the employees of Jager Di Paola Kemp Design and located in the basement of JDK Headquarters at 47 Maple Street.

"Sanctuary provides a forum for unique, individual expression, shared knowledge, and diverse points of view while emphasizing the artist's search for truth amidst modern-day hype and information over load."

Since 2002, the gallery has presented exhibits of colorful, hip, vibrant work.

Green Door Studio

18 Howard Street (off Pine Street behind Speeder & Earl's)
Burlington 05401
(802) 862-0840-Unsworth Properties
www.greendoorstudio.net
drew@greendoorstudio.net
The Studio is open by appointment or by invitation. Call or e-mail to be added to the mailing list.

This artist-run collective is located in the Howard Spaces in Burlington's South End. From May through October, the gallery features work from an array of artists. The collective also operates a community darkroom, a fully equipped papermaking and bookbinding studio and five personal artist spaces.

E1 Studio Collective

416 Pine Street (behind Speeders and Earl's in the Alley)
Burlington 05401
(802) 324-4019
The Studio is generally open Monday to Friday from 10 a.m. to 6 p.m. or
by appointment

E1 is a collection of studios and common gallery space. Membership isn't
static, but the collective is maintained by a core group of artists-Terry Zig-
mund, Wylie Garcia, Christina Conant, and Christy Mitchell-who share a
common goal of promoting the art of the individuals as well as art by local
artists. A total of seven artists work in the space. Calls to artists, openings, and
exhibition announcements can often be found in Seven Days.

Burlington Community Glass Studio

416 Pine Street (behind Speeders and Earl's in the Alley)
Burlington 05401
(802) 324-4019
www.burlingtonglass.net
The Studio is generally open Monday to Friday from 10 a.m. to 6 p.m. or
by appointment

Burlington Community Glass Studio is a stained glass design studio special-
izing in the creation of residential and commercial commissions and classes
in stained glass design, mosaic design and silk painting. The owner, Terry
Zigmund, teaches for the Community College of Vermont and Burlington
City Arts and independently. Burlington Community Glass also offers open
studio space for other glass artists. In 2001, Terry facilitated the September
11 Remembrance Window, a project created by students in her stained glass
class; this commemorative window is displayed at The Community College of
Vermont in Burlington.

Flynndog

208 Flynn Avenue
Burlington 05401
(802) 863-2227 - fax (802) 863-0093
www.flynndog.com
The Flynndog is open weekdays from 8 a.m. to 5 p.m.

Located in a once-abandoned warehouse, Flynndog presents traditional and non-traditional exhibitions, as well as community-based events. The artists maintain a gallery presence and handle sales. The Flynndog website provides a brief history of exhibitions featured since 1999.

ART AND FURNITURE

Burlington Futon Company

388 Pine Street
Burlington 05401
(802) 862-5056
www.burlingtonfuton.com

Occasionally, the Burlington Futon Company presents exhibitions of local artists.

ART AND FOOD

Café Piccolo

431 Pine Street
Burlington 05401
(802) 862-5515

This soup, salad, and sandwich joint also has rotating art exhibits by local artists.

Speeder & Earl's

412 Pine Street
Burlington 05401
(802) 849-6041
www.speederandearls.com

Speeder & Earl's is Burlington's hometown coffee roaster. Their Pine Street store sports local artwork.

University of Vermont

Founded in 1791, UVM is the fifth oldest university in New England. UVM, which stands for Universitas Viridis Montis (Latin for "University of the Green Mountains"), serves approximately 10,000 students on a quintessential New England campus. UVM is the state's only university. Located on "the Hill" in Burlington, the 450-acre campus has three sections: Main, East, and Redstone Campuses. Four art venues are of particular note. These venues serve students and faculty, members of the larger community of Burlington, and visitors.

Parking can be challenging. If possible, visitors can take a shuttle from Church Street Marketplace which runs up and down College Street to the University. The campus is very pedestrian friendly. Otherwise, it is advised to call ahead to a venue and ask for parking suggestions.

McCrorey Gallery of Multicultural Art

Bailey/Howe Library, Central Campus
University of Vermont
Burlington 05405
(802) 656-8205
http://bailey.uvm.edu/ref/tour/mccrorey.htm
Call for hours.

A dual-use space located on the main floor of the Bailey/Howe Library, The McCrorey Gallery of Multicultural Art explores themes of racism, social justice, and diversity. It is one of the few permanent spaces in Vermont dedicated to work by artists of color. The work is presented on the walls of a large open study area for students. Work on display rotates regularly. The Gallery is open anytime the library is, but viewing the work can be difficult at some points during the academic year-midterms, finals, etc.-when the space is packed with students working and studying.

Robert Hull Fleming Museum

University of Vermont
61 Colchester Avenue
Burlington, VT 05405
(802) 656-0750
www.uvm.edu/~fleming

The Museum is open year-round. From Labor Day to April 30th, the Museum is open Tuesday through Friday from 9 a.m. to 4 p.m.; and on Saturday and Sunday from 1 to 5 p.m. Between May 1st and Labor Day, the Museum is open Tuesday through Friday from noon to 4 p.m.; and on Saturday and Sunday from 1 to 4 p.m. Always closed on Monday.

The Fleming has a permanent collection of 20,000 objects that includes art and artifacts from as early as Mesopotamia and as recent as the 21st century. The collection began in 1826 and over the years has served as both a repository for art and artifacts as well as an instrument for collecting. More recently, the museum staff has taken a more systematic, planned approach to acquisition.

On permanent display is art from the Middle East, China, Japan, India, Egypt, and Africa as well as a large collection of European and American art. The museum hosts nine exhibits a year in three changing galleries. Exhibitions may be traveling shows or exhibitions curated from the museum's own collection. Rotating exhibitions tend to be fresh and extremely well curated and accompanied by gallery talks, art lectures, concerts, and other events.

The other reason to visit the Fleming is the building itself. Built in 1931 to house a growing collection, the Fleming is exemplary of the Colonial Revival style. Red brick walls are bordered by white wood trim. The building includes a delightful collection of details--balustrades, pilasters, pediments, and entablatures--which mark early American architectural styles. The architect of the Fleming Museum was William Mitchell Kendall whose firm, the prestigious McKim, Mead, and White, also designed several other buildings on campus, namely Ira Allen Chapel and the Waterman Building.

One enters the museum through what was originally the rear and what is now a handicapped accessible reception area completed in 1984. Through the original back brick wall of the museum, one enters the Wilbur Room, a walnut paneled room with a groin-vaulted, white plaster ceiling, from which a large brass chandelier hangs prominently. Continuing through the building, one enters the Marble Court marked by classic columns and a grand marble staircase.

Robert Hull Fleming Museum at the University of Vermont in Burlington.

Francis Colburn Gallery

Williams Hall, Second Floor
University of Vermont
Burlington 05405
(802) 656-2014
www.uvm.edu/~colburn
The Gallery is open weekdays from 9 a.m. to 5 p.m. during the academic
year.

Williams Hall, a classic brick structure draped in ivy, houses the university's
art department and its exhibition space, the Francis Colburn Gallery. One of
the best kept secrets in Burlington, the Colburn Gallery regularly shows world-
class contemporary artists from Montreal, New York, and Vermont. It tends to
be more active during the academic year. The space is located on the Second
Floor at the top of the central staircase. Call ahead to confirm an exhibition is
showing and that the gallery will be open.

The Living/Learning Center Gallery

Near the Fireplace Lounge on Level 2
Living/Learning Commons Building
633 Main Street
University of Vermont
Burlington 05405
(802) 656-4200 or 656-4211
www.uvm.edu/llcenter/happen.htm#gallery
The Gallery is open Monday through Friday from 12:30 to 8:30 p.m. and on
Saturdays from 12:30 to 4:30 p.m. during the academic year.

The Living/Learning Center is a residential hall at the University of Vermont
where students live in interest-specific housing. Among other things, The
Center has a darkroom and a pottery center that is open to students. The gal-
lery shows a range of work by students and artists. The work is often political.
We suggest calling ahead to get detailed instructions on how to access the
gallery and parking information. It's worth the effort.

Events in Burlington

MAY-OCTOBER
First Friday Art Walk, Burlington
Downtown Burlington
(802) 865-7551
www.burlingtoncityarts.com/firehousegallery/firstfridayartwalk/
Galleries all over Burlington participate in this gallery walk that happens May to October. New art spaces are added regularly. Many of the galleries are in and around Church Street. The art walk takes place from 5 to 8 p.m. Tours of the galleries leave from the Firehouse Gallery on Church Street starting at 5:30 p.m. The last tour is at 7 p.m.

MAY-OCTOBER
Firehouse Gallery Artist Market, Burlington
Firehouse Plaza, City Hall Park
(802) 865-5356
www.burlingtoncityarts.com/firehousegallery/artistmarket/
Held in conjunction with the Farmers Market on Saturdays from May to October, 10 a.m. to 3 p.m. (weather permitting). The Artist Market provides artists with an opportunity to sell their work on the Firehouse Plaza next to City Hall Park in Downtown Burlington.

JUNE
Art's Alive, Burlington
(802) 864-1557
Each June, the folks of Art's Alive turn Church Street in Burlington into a huge gallery. You'll see contemporary works by Vermont artists in windows and shops throughout the Church Street Marketplace.

SEPTEMBER
South End Art Hop, Burlington
From Main Street to Flynn Avenue, largely along Pine Street
(802) 859-9222
www.seaba.com
In addition to being home to more than thirty galleries, studios, and other art-related businesses, the Burlington's South End is the hub of the city's creative economy. The district also has nearly twenty outdoor sculptures. The South End Art and Business Association holds an annual art hop in September and the program for the event also serves as a guide to the areas art spots and sculptures.

ADDISON COUNTY

Middlebury ◆ Frog Hollow ◆ Middlebury College
Bristol and Five Towns ◆ Northwest Addison
Shoreham

Sometimes called the Bread Basket of Vermont, Addison is a dedicately rural county situated between Burlington to the north and Rutland to the south. The Green Mountains border the county to the east and Lake Champlain makes the western border.

Primarily agricultural communities, Addison County boasts a respectible art and craft tradition with many working contemporary artists, most notably Tad Spurgeon, Reed Prescott, and Norton Latourelle. Addison County is also the home of Middlebury College, a small liberal arts school that has a remarkable museum and collection of public art.

Middlebury is the largest town in Addison County. It serves as the county seat as well as the home of Middlebury College. Middlebury has a classic Vermont downtown built around the falls of Otter Creek. In addition to a large green, the town is a pleasure to walk through, very pedestrian friendly, and full of 19th century architecture

Bristol is a progressive little town in the northeast corner of Addison County, accessible by route 17 from the west and route 116 from the north or south. Nestled in the foothills of the Green Mountains, Bristol is the shire town for four surrounding communities: Starksboro, Monkton, New Haven, and Lincoln.

The area has a long history of creativity and the surrounding countryside is dotted with artists, writers, craft makers, and artisans. Two great times to visit the area are Memorial Day weekend when Lincoln holds its annual town-wide yard sale which happens to coincide with Vermont's Open Studio Weekend (See page 197), and Fourth of July when Bristol puts on the quintessential small town celebration of Independence Day complete with Outhouse Races that are better seen than explained.

Bristol boasts a Main Street and a town green complete with a gazebo where weekly band concerts are held in summer. The town has been going through a renaissance the last few years. The 1998 flood that tore through roads just north of town resulted in new, shiny twin bridges over the New Haven River. With the addition of Bobcat Café, fine dining has doubled. The outmoded Main Street Diner has been usurped by the slightly hipper Snaps. In the middle of this revitalization, two new art venues have taken root: Art on Main and Walkover Gallery.

In Northwest Addison County, one finds themselves in the smallest city in the United States, Vergennes. As in Middlebury, one finds a impressive collection of early 19th century architecture. Vergennes is the home of the Blue Moon Gallery, which has a nice selection of fine and folk art. Across the street, on the way to the impressive falls on Otter Creek, which runs through town is the impressive Greek Revival-style Bixby Memorial Library.

Ferrisburgh lies both west and north of Vergennes. To the west, on Lake Champlain, the not-to-miss art event of the year in Addison County is a juried art show that takes place at the Basin Harbor Club every August. (See the Event listing at the end of this chapter.)

On Route 7 in between Vergennes and Charlotte sits the Old Ferrisburgh Depot, a short ramble of buildings that include the now out of use rail station, a covered bridge, and a mid-eighteenth century brick Queen Anne. In recent years, the small area saw revitalization when the now defunct Ferrisburgh Artisans Guild organized a cooperative gallery in the old house and painted murals on the floor of the covered bridge. Starry Night, an upscale bistro moved into one of the buildings and the area became something of a destination for area foodies and art lovers.

The old brick building north of the covered bridge houses Gallery Seven North; Starry Night still attracts food lovers from around the state; and Human Hand Gallery and Studios occupies the old depot.

Middlebury

Last Green Place Fine Art Gallery

72 Court Street (Route 7)
Middlebury 05753
(802) 388-3131 - fax (802) 388-2478
www.lastgreenplace.com
The Gallery is open weekends in season (June - October), Saturday 11 a.m. to
6 p.m. and Sunday 12 noon to 5 p.m., by appointment or by chance.

Last Green Place Fine Art Gallery is a festive, yet relaxed gathering place
for artists and art enthusiasts in Middlebury. The gallery features fine art by
Vermont and Northeast United States contemporary artists with a focus on
one-of-a-kind oil paintings in a representational style and wooden gear clock
sculptures.

Vermont Folklife Center

3 Court Street
Middlebury 05753
(802) 388-4964
www.vermontfolklifecenter.org
The Gallery and Shop are open Tuesday through Saturday, 11 a.m. to 4 p.m.
The office is open Monday through Friday from 9 a.m. to 5 p.m. and the
Research Center is open Monday through Friday from 10 a.m. to 4 p.m.
Admission is free.

Since 1984, the Vermont Folklife Center has been celebrating the state's
heritage by preserving and presenting folk art, oral histories, and cultural
traditions. They conduct ongoing field research, support a growing archive,
and teach other people how to collect and preserve history.

At their center in Middlebury, Vermont Folklife operates a gallery with a
variety of rotating exhibits. They sometimes present photographers whose
work is best described as social documentary. The Folklife Center is worth
keeping an eye on.

Holy Cow, Inc.
44 Main Street (Route 30)
Middlebury 05753
(802) 388-6737
www.woodyjackson.com
Holy Cow is open Monday through Saturday from 10 a.m. to 5 p.m. and
Sunday from 12 noon to 4 p.m.

If you come across someone who immediately thinks of cows when they think
of art in Vermont, Woody Jackson is the reason why. The Middlebury artist
has been painting and printing his signature Holsteins for over twenty years. In
1983, a small, but growing ice cream maker named Ben & Jerry's purchased
the rights to use Woody's cow as a trademark. A brand was born!

At Holy Cow, Jackson offers original watercolors to limited edition prints as
well as a never ending list of fun products: mugs, calendars, t-shirt, glassware,
switch covers, towels, and even golf balls. Oh yeah, Woody paints dogs too.

Holmes Studio
50 Sheep Farm Road
Weybridge 05753
(802) 545-2824
www.deborahholmeswatercolors.com
The Studio is open from Memorial Day to Labor Day on Saturdays from 1 to 5
p.m. At other times, by appointment or chance.

In the heart of farm country outside of Middlebury, Deborah Holmes wel-
comes guests to her home gallery and studio located in her farmhouse.

"I have drawn and painted since childhood. It is simply what I like to do best.
I paint every day at my studio in town, on location or at home. I love painting
outdoors when it's warm enough because it's all right there...the light, the
smells, and the color."

Painting in watercolor, Vassar-educated Holmes paints Vermont landscapes,
scenery, and agricultural life. She sells prints and original watercolors.

Mike Mayone Fine Art

8 Case Street (Route 116)
Middlebury 05753
(802) 388-7041
www.mikemayone.com
The Studio is open by appointment and by chance, but generally at least
Wednesday and Thursday from 9:30 a.m. to 5 p.m.

Self-taught, Vermont fine artist Mike Mayone enjoys making a career of what
comes naturally. Mayone paints detailed, photorealistic landscapes. He offers
original acrylics and oils, limited edition giclee and lithograph prints and fine
art note cards. His work can be seen a number of shops and galleries around
Vermont. His studio is open by appointment and by chance.

Great Falls Fine Art Center

Frog Hollow Alley (off of Mill Street, by the Otter Creek Falls)
Middlebury 05753
The Center is open Tuesday through Saturday from 10 a.m. to 5 p.m.

Located next to the Otter Creek Falls, the Great Falls Fine Art Center shows
painting and sculpture by over 20 artists from around Addison County and
Vermont. There is also a café. An interesting feature of the gallery is the
window in the rear that overlooks one of the spillways of the old mill.

Tom Homann Pottery

3 Warner Drive
Middlebury 05753
(802) 388-1072
Open most days, call for hours.

Tom Homann began working in clay in 1974 and has been a full-time potter
for over twenty years. His work consists of high fire mostly ash glazed
stoneware. Homann uses functional work such as teapots, bowls, and vases as
a means of expresssion.

Walter Cerf Gallery at the Henry Sheldon Museum of Vermont

1 Park Street
Middlebury 05753
(802) 388-2117
www.henrysheldonmuseum.org/gallery.html
The Museum is open Monday through Saturday from 10 a.m. to 5 p.m. An admission fee is charged.

While primarily a museum of local history, work of local contemporary artists are sometimes exhibited at the Henry Sheldon Museum of Vermont in their the Walter Cerf Gallery. Built in 1991, and paid for largely by the art dealer and philanthropist whose name it bears, the gallery is a fresh addition to the museum, which was founded in 1882.

Believed to be the oldest community museum in the United States, the Sheldon Museum is a staple of cultural life in Middlebury. They present a range of community programs, lectures, and programs for children. The home of the museum is a three-story brick Federal house that was built in 1829. The marble details are a testament to the region's marble industry.

Ilsley Public Library

75 Main Street (Route 30)
Middlebury 05753
(802) 388-4095
www.ilsleypubliclibrary.org
The Library is open Monday, Wednesday and Friday from 10 a.m. to 6 p.m.; Tuesday and Thursday from 10 a.m. to 8 p.m.; and Saturday from 10 a.m. to 4 p.m. From October through April, the Library is also open Sunday from 1 to 4 p.m.

Ilsley Library is a venue without a formal exhibition program. Artists often approach the library about exhibiting their work in the main room. Artists promote the exhibition themselves and therefore it is sometimes hard to find out what's on view. Enter the main door of the library and go to the room to your right and look up. Work is exhibited above the bookcases.

Frog Hollow
Vermont State Craft Center

Known simply as Frog Hollow for short, this arts organization has been a Vermont institution since 1971. It started as an after-school pottery program for young people and now includes three nationally known galleries showing over 250 juried artisans and artists and an extensive range of classes for young people and adults. Frog Hollow has centers in Burlington, Middlebury, and Manchester. (See page page 37 for Burlington and page 94 for Manchester.) Each location has a distinct flavor.

"Our mission is to develop and strengthen the vibrant connection to the creation, appreciation and support of fine Vermont craft through education, sales, and exhibition."

While the Frog Hollow is primarily focused on craft, it does show some fine art. The work of three artists in particular seems to be synonymous with Frog Hollow. Sabra Field is known around the world for her prints that celebrate the land in Vermont. Stephen Huneck's whimsical dog-themed prints are certain to bring a smile. (See page 154 for more information.) Newcomer dug Nap shows witty, cartoon-like cards and posters. (See page 38 for more information.)

Frog Hollow also operates craft schools at its Middlebury and Manchester locations. Classes are taught by local artisans and craftspeople. Frog Hollow offers classes for all ages, with a special emphasis on programs for young children. Each location produces four to six special exhibits each year of local and national artisans. Frog Hollow also operates an online gallery and store.

Frog Hollow Middlebury
One Mill Street
Middlebury 05753
(802) 388-3177
www.froghollow.org
The Gallery is open Monday through Saturday from 10 a.m. to 5:30 p.m. and Sunday from 12 noon to 5 p.m.

In an old mill building converted into a stylish space and set dramatically against the rushing Otter Creek Falls. Visit neighboring small cafés and one-of-a-kind shop.

ART AND FOOD

Tully & Marie's Restaurant
7 Bakery Lane
Middlebury 05753
(802) 388-4182
www.tullyandmaries.com

New American cuisine and local art in an art deco-inspired restaurant over-looking Otter Creek. Exhibits rotate.

Carol's Hungry Mind Café
24 Merchant's Row
Middlebury 05753
(802) 388-0101

A fairly recent addition the Middlebury scene, the café shows work by local artists and serves up standard coffeehouse fare.

Middlebury College

One of country's premier liberal arts colleges, Middlebury has an international reputation. During the traditional academic year, Middlebury offers a rigorous liberal arts program. In the summer months, the main campus becomes an intensive language school and Bread Loaf campus becomes a School of English. The eleven-day Bread Loaf Writers' Conference brings over 200 writers to the area for an intensive exchange about the art of writing.

In 1992, the college opened the Middlebury College Center for the Arts. This hub serves as the main performing arts facility and houses the Middlebury College Museum of Art. It also houses Rehearsals Café. Public art can be found throughout the Middlebury campus.

As with most educational institutions in Vermont, Middlebury's arts programs serve the students and faculty while also making themselves available to the wider community. Visual arts are a strong component of its program that also includes music, dance, film, and theatre. One of the wonderful things about Middlebury that it consistently presents world-class performers in small auditoriums and other intimate settings. These events are well-produced and open to the public.

Public Art at Middlebury College
Campus-wide
Route 30
Middlebury 05753
(802) 443-5007
www.middlebury.edu/arts/capp/

The campus of Middlebury College is speckled with shining examples of public art. You can picnic across a pond from Robert Indiana's *LOVE* and Clement Meadmore's geometric, yet fluid *Around and About*. Or contemplate the subtlety of Joseph Beuys's *7000 Oaks*, an ever changing, organic piece that includes a basalt stone and a tree planted in 1998. Since 1994, the college has had a "One Percent for Art" policy that earmarks "one percent of the cost of any renovation or new construction at the college for the purchase, installation, maintenance, and interpretation of works of art in the public places." The fund is administered by the Committee on Art in Public Places, which is made up of faculty, students, administrators, and trustees.

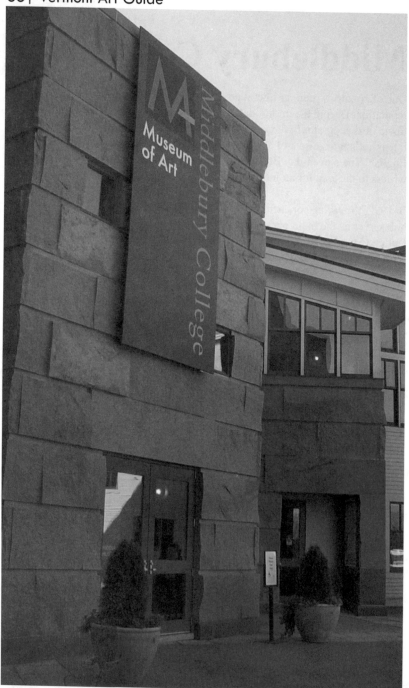

Middlebury College Museum of Art.

Middlebury College Museum of Art at the Center for the Arts

Route 30
Middlebury 05753
(802) 443-5007
www.middlebury.edu/arts/museum

The Museum is open Tuesday through Friday 10 a.m. to 5 p.m. and Saturday and Sunday 12 noon to 5 p.m. Closed Mondays, all College holidays, the week between Christmas and New Year's Day, and the last two weeks of August.

The Middlebury College Museum of Art is one of Vermont's best art facilities. Highlights of the college's permanent collection include antiquities and distinguished collections of Asian art, photography, 19th-century European and American sculpture, and contemporary prints. Tours, lectures, and family programs are offered.

The museum features traveling exhibitions. Past exhibitions have included contemporary garden photography, Latin American graphic arts, still life and trompe l'oeil paintings from the Oscar and Maria Salzer Collection, and, more recently, video installations.

The museum also presents contemporary art in an ongoing exhibition series called "Art Now." This has included the photorealist painting of Chicago artist James Valerio and a hologram portrait of president emeritus John M. McCardell.

Bristol & Five Towns

Art on Main

25 Main Street (Routes 17 and 116)
Bristol 05443
(802) 453-4032
www.artonmain.net
The gallery is open Tuesday through Saturday from 10 a.m. to 6 p.m. and Sunday and Monday by chance or appointment.

Tucked behind Deerleap Books, Art on Main is a cooperative community art center and gallery. On display is work that is juried and includes visual art as well as crafts and other products. Of particular note for the contemporary art seeker is Victoria Blewer's hand-colored photographs, Mike Mayone's photorealistic oil and acrylic paintings, and the highly stylized paintings of Patricia LeBon-Herb whose abstract-representationalism is influenced by German and Flemish expressionists. Artists on display rotate frequently and its best to check the website to see who's work is on display before visiting.

In June 2005, Bristol Friends of the Arts unveiled Artist's Alley next to Art on Main, which serves as a mini-mural and sculpture park. A permanent installation of five murals titled "The Spirit of Vermont" line the path.

The mural artists are Jean Cannon, Brenda Myrick, Mark Benton, Colette Paul and Rachael Rice. A creative declaration of community spirit, the murals and the tiled benches which were created by sixth graders from the five town area under the supervision of landscape architect Katie Raycroft-Meyer are reflective of the region's unassuming and populist approach to art.

ART AND FOOD

Bobcat Café

5 Main Street (Routes 17 and 116)
Bristol 05443
(802) 453-3311

A newer addition to Bristol, Bobcat Café offers high-end pub and bistro fare in a beautiful setting with rotating work by local artists.

Artist's Alley at Art on Main Street in Bristol.

Walkover Gallery

15 Main Street, upstairs (Routes 17 and 116)
Bristol 05443
(802) 453-3188
The Gallery is open Monday through Friday from 9 a.m. to 5 p.m. and
weekends by chance.

Karen Lueders's Walkover Gallery shows a mix and match of local artists
whose work is sometimes unusual and challenging. The gallery is housed in
the old First National Bank, an old brick building with arching windows. In
addition to art exhibits, Walkover Gallery also presents the occasional concert.
The gallery is upstairs, and the receptionist at the front desk can direct you.

Robert Compton Pottery

2662 North 116 Road (Routes 17 and 116)
Bristol 05443
(802) 453-3778
www.robertcomptonpottery.com
The studio is open Mid-May through Mid-October from 10 a.m. to 6 p.m.
Closed Wednesdays. Off-season hours are by chance.

This working pottery and gallery is located in rural Vermont on a former dairy
farm. The barn serves as a clay studio and pastures are used for raising sheep.
The farmhouse provides space for a gallery and is home to Robert, Christine
and their Golden Retriever, Shino. Robert's far-reaching interest in clay has led
him to build a wide assortment of kilns. Choosing to fire a Noborigama, Pit,
Salt, Raku or Gas Fired Car Kiln, he is able to make pottery that reflects the
unique qualities of each of these processes.

ART AND FOOD

Bristol Bakery

14 Main Street (Routes 17 and 116)
Bristol 05443
(802) 453-3280

The hub of Bristol community life, the bakery sometimes shows photographs
and other art, often of people's travels to foreign lands.

Prescott Galleries

47 East River Road
Lincoln 05443
(802) 453-4776
www.prescottgalleries.com
The Galleries are open from May 1st to December 31st on Tuesday, Friday and Saturday from 10 a.m. to 5 p.m. All other times, the Galleries are open by appointment.

Up the mountain fron Bristol, along the winding, appropriately named River Road, in the heart of Lincoln, you will find this gallery. A charming artist-run space shows almost exclusively work by Reed Prescott.

An oil painter and illustrator, Prescott is most known for being the first Vermonter to win the Vermont Duck Stamp competition. Prescott is a naturalist, realist painter whose subject ranges from images of New England life to waterfowl and other wildlife. Original work, giclee prints, and an assortment of notecards and books are available at the gallery.

The Lincoln Library

222 West River Road
Lincoln 05443
(802) 453-2665
www.lincoln.lib.vt.us
The Library is open Monday from 2 to 7 p.m.; Wednesday from 10 a.m. to 8:30 p.m.; Friday from 10 a.m. to 2 p.m.; and Saturday from 10 a.m. to 4 p.m.

In 1998, a flood ruined the Lincoln Library. Out of the dank marsh that remained, a new building and a renewed community spirit rose....on higher ground. The new facility often has exhibits of artwork by artists from the surrounding area.

Northwest Addison

Black & White and Color

3367 Monkton Road
Vergennes 05491
(802) 877-2526
www.blackwhiteandcolor.com
The gallery is open Mid-June to mid-October, Thursday through Saturday 11 a.m. to 4 p.m. and by appointment.

Judith and Denis Versweyveld show and make work in two old barns that were moved to the site to serve as their studio and gallery. The subject of Denis's work concerns everyday objects found in and around his home and studio. Judith paints flowers from her garden, fruit, landscapes, and other common objects. Their work is simple, elegant, and natural. On view and for sale are acrylic and oil paintings; prints; bronze, plaster, and cement sculpture; and crafts.

Robert Popick Studio

498 Route 66 (between Green Street and Maple Street)
Waltham 05491
(802) 977-3323
By appointment, it's best to call ahead.

Located in a 19th century hill farm setting, on view is Robert Popick's original watercolor and oil paintings of New England landscapes. Popick paints with an eye for detail and a romantic view of the land.

Finding this gallery may be a challenge. The street signs marking Route 66 are regularly stolen. Travel about three miles south from Vergennes on Green Street, Route 66 is on your right. A paved turn quickly becomes dirt road. Once you find Route 66, a prominent sign marks the driveway.

Bixby Memorial Library

285 Main Street (Route 22A)
Vergennes 05491
(802) 877-2211
www.vergennes.org/bixby/
The Library is open Monday and Friday from 12:30 to 8 p.m.; Tuesday and
Thursday from 12:30 to 5 p.m.; Wednesday from 10 a.m. to 5 p.m.; and
Saturday from 10 a.m. to 2 p.m.

This impressive Greek Revival-style building, opened in 1912, has ongoing
exhibits by local artists on the first floor. The center of the library is a rotunda
covered by a large stained glass dome.

Blue Moon Gallery

245 Main Street (Route 22A)
Vergennes 05491
(802) 877-9900
The Gallery is open Tuesday through Saturday from 11 a.m. to 4 p.m.

This small, narrow gallery has local folk and fine art as well as an assortment
of small items, antiques, and crafts. Work by a number of artists including
Judith Rey, Jill Madden, watercolorist Robert Popick, folk artist Jim Bushey,
and painter Eloise Biel.

Smith-Hunter Gallery

4234 Route 7
Ferrisburgh 05456
(802) 877-3719
www.smithhuntergallery.com
The Gallery is generally open Friday to Monday from 11 a.m. to 5 p.m.,
during the week by chance (look for the sign out front), or call for appointment

Located off Route 7, The Smith-Hunter Gallery presents the work of husband
and wife artists Susan Smith-Hunter and Mel Hunter. Susan is a sculptor who
creates ceramic figurative work. Mel, who passed away in February 2004, was
an illustrator and lithographer whose work often concerned the natural world.
A few pieces by other artists are also available.

Human Hand Gallery & Studio

5359 Route 7
Ferrisburgh 05456
(802) 877-3333
www.humanhandgallery.com
Human Hand is open Wednesday and Thursday from 10 a.m. to 6 p.m.; Friday and Saturday from 10 a.m. to 10 p.m.; and Sunday from 11 a.m. to 5 or 6 p.m. Hours change with the season.

In creating Human Hand, curator/owner/director Carol Schreiber wanted to create a different sort of gallery. She wanted a community-oriented space that was comfortable and upfront. She wanted to offer activities that would bring out and foster the creative urges of young and old alike. She wanted to develop long-term, mutually beneficial relationships with artists. And she wants to be the center for art and creativity in the region. She is well on her way.

Human Hand Gallery & Studio shows Vermont fine art and craft. It currently shows work by 15 artists but the number is growing. Stock rotates frequently and it's not uncommon to return a week later and find a whole new layout to the space. Each month a different artist is featured as well as a children's gallery with work for sale. Human Hand offers classes for adults and children and a dynamic program of community activities.

Gallery Seven North

5467 Route 7
Ferrisburgh 05456

In the same complex that houses Human Hand Gallery and Starry Night Café, Gallery Seven North offers contemporary art, old art, and an array of other items including a fascinating assortment of stuffed animals.

Shoreham

Norton's Gallery
Route 73 near the Orwell-Shoreham Town Line
Shoreham 05770
(802) 948-2552
www.nortonsgallery.com
The Gallery is generally open from 9 a.m. to 5 p.m. and by appointment.

Close to Middlebury, a short side trip to Shoreham takes you to the gallery and studio of renowned sculptor and folk artist Norton Latourelle. On view are colorful wood carved dogs, birds, and other animals. The whimsical sculpture park around the studio has fantastic vistas of Lake Champlain and the Adirondacks. During the off-season, it's best to call ahead.

Events in Addison County

AUGUST
Reflections on Basin Harbor Art Exhibit, Ferrisburgh
Basin Harbor Club
(802) 475-2311
www.basinharbor.com/reflections.asp
This juried art show is held the 10 days prior to Labor Day. The program was started when Basin Harbor celebrated its centennial in 1986. The show focuses on Vermont artists' interpretations of Basin Harbor. Over 1,000 works on this theme have been created since the show's inception.

RUTLAND COUNTY

Brandon ◆ Rutland ◆ Along Route 4

At the crossroads of US Routes 4 and 7, Rutland County is bordered by Addison County to the north, the ski town of Killington to the east, New York's Taconic Mountains to the west, and Bennington County to the south. The Victorian mansions, old rail tracks, and country estates hint at the area's 19th century prosperity.

Brandon, in the north, has seen a renovation to its downtown in recent years that included the opening of Café Provence, a high-end eatery by New England Culinary Insititute and French-born chef Robert Barral. The upswing has coincided with the formation of the Brandon Artists Guild and the opening of the Warren Kimble Gallery, making Brandon a destination for folk artists. Fran Bull's contemporary art Gallery In-the-Field balances the town's folksy tradition with cutting edge art.

The City of Rutland, many years Vermont's second city, has long been overshawdowed by growth in Chittenden County. Commercial vacancies in downtown Rutland are crying out for an artist invasion, but it hasn't seemed to happen yet. A few downtown venues hold ground in this art frontier.

Along Routes 4 and 4A, you will find pockets of art in the Rutland County towns of Killington, West Rutland, Castleton, and Poultney.

Brandon

Gallery in-the-Field

682 Arnold District Road
Brandon 05733
(802) 247-0125
www.galleryinthefield.com
The Gallery is open Saturday and Sunday from 1 to 5 p.m. and by appointment.

"We will provide a forum for the sharing of issues and questions raised in the context of the art. We want to be a venue for teaching and learning, where people leave inspired to experiment and to create."

Gallery in-the-Field is the creation of artist Fran Bull who settled in Brandon in 1999. The gallery, which opened in 2005, is a showcase of national artwork and local performances. The building was designed and built by the McKernon Group as a gallery space. It is situated on rolling land with views the Green Mountains. Work on view includes Fran Bull's sculptural compositions; Sally Pleet's constructions, collages, and paintings; as well as work by Michael Andre, Kryste Andrews, Katie Bull, Carolyn Corbett, and Joe Fonda.

Brandon Artists Guild

7 Center Street (Route 7)
Brandon 05733
(802) 247-4956
www.brandonartistsguild.org
The Guild is open daily from 11 a.m. to 6 p.m.

In 2001, a group of five artists got together to promote art in the Brandon area. The Brandon Artists Guild was born. A non-profit organization, the Guild organizes projects such as the very popular Really, Really Pig Show and more recently, Brandon Rocks, a season long event where artists exhibit painted rocking chairs throughout the area. The Guild maintains a cooperative gallery space at 7 Center Street in downtown Brandon which has work by a number of members.

Liza Myers Gallery and Studio

22 Center Street (Route 7)
Brandon 05733
(802) 247-5229
www.lizamyers.com
The Gallery and Studio are open Monday to Saturday, 10 a.m. to 5:30 p.m.
and Sunday 12 noon to 4 p.m.

The work of painter, sculptor Liza Myers is the subject of this downtown
Brandon gallery. Interested in nature and ecology, Liza paints wildlife, florals,
and fauna. On view is original work in watercolor, oil, acrylic, and clay.
Giclees and notecards are also for sale at the gallery, which doubles as a frame
shop run by the artist's husband. Liza teaches extensively and offers classes
for both children and adults.

Artisans at the Bend

35 Franklin Street (Route 7)
Brandon 05733
(802) 247-6637
www.artisansatthebend.com
The Studio is open by appointment.

Folk artists Robin Rodda Kent and Jim Barner relocated to a Vermont barn
on Route 7 just south of Brandon. The sculptures and painters create folksy,
figurative work that has been collected by the American Folk Art Museum and
sells at galleries across the United States.

Medana Gabbard Gallery

1340 Grove Street (Route 7)
Brandon 05733
(802) 247-5520
www.brandonfolkart.com
The Gallery is open daily, except Wednesday, from 10 a.m. to 6 p.m. and
Sunday from 10 a.m. to 4 p.m.

Folk artist Medana Gabbard creates nostalgic work of Americana at her
gallery/studio just north of Brandon on Route 7. The gallery also has work by
Michael Fratrich and artists Edward Galda, Senior and Junior. While original
work is the emphasis of the gallery, prints are also available.

Warren Kimble Gallery in Brandon.

Warren Kimble Gallery

4 Conant Square (Route 7)
Brandon 05733
(802) 247-3026
www.warrenkimble.com
The Gallery is open from June to October, Monday to Friday 9 a.m. to 5 p.m. and weekends 10 a.m. to 4 p.m. From November to May, Monday to Friday 10 a.m. to 5 p.m. and weekends 10 a.m. to 4 p.m.

Warren Kimble's gallery is a showcase for what he describes as a "new style" of contemporary American Folk Art. His work consists of stylized landscapes, seascapes, animals and other subjects on dinnerware, wall and floor coverings, furniture, textiles and decorative accessories, as well as on canvas. The gallery includes original fine and folk art paintings, a museum of Kimble's paintings, a collection of folk art from Kimble's private collection, signed prints, and a gift shop. Kimble's private studio is in a renovated barn loft off site.

Chaffee Center for the Visual Arts in Rutland.

Rutland

Chaffee Center for the Visual Arts

16 South Main Street (Routes 4 and 7)
Rutland 05701
(802) 775-0356
www.chaffeeartcenter.org
The Center is open Monday through Saturday from 10 a.m. to 5 p.m., and on Sunday from 12 noon to 4 p.m. The Center is closed on Tuesday.

For over forty years the Chaffee Center for the Visual Arts has been promoting art in Rutland. Originally the Rutland Art Association, the group changed its name in 1982 to the Chaffee Arts Center after it purchased the historic residence it had occupied on loan from the Chaffee family since 1961.

While the building's interior features maple and oak woodwork, and elegant parquet floors, the outside is equally marvelous with a Syrian arch front, a porte cochere, a three-story corner town with a conical roof, and a smaller conical tower with gothic windows. One shouldn't miss the 85-year-old Christmas cactus on the second floor.

The 1896 Queen Anne Victorian mansion is home base for a number of Rutland County artists. A juried membership organization, the Chaffee curates eight exhibitions a year, largely, but not entirely from member's work. Nearly all media are represented. Visitors to the Chaffee will see the entire three-story mansion filled with art

The Chaffee Center for the Visual Arts offers a variety of art classes for all ages and abilities.

Night Owl Gallery
& Moon Brook Gallery of Art

30 Center Street (in the lobby of the Paramount Theater)
Rutland 05701
(802) 775-5800
The Gallery is open Tuesday to Thursday, 10 a.m. to 3:30 p.m.

Night Owl Gallery and Moon Brook Gallery of Art exist side by side in the lobby of the Paramount Theater in downtown Rutland. Brenda Kelly curates Night Owl Gallery which presents work by local artists. Moon Brook is a twenty-five year old artist cooperative. Exhibits rotate every month or two.

Wilson Castle

West Proctor Road
Center Rutland 05736
(802) 773-3284
www.wilsoncastle.com
The Castle is open daily from 9 a.m. to 6 p.m., last tour starts at 5:30 p.m., Memorial Day to October 31st. An admission fee is charged.

One of the many features of this privately owned 19th century architectural masterpiece is an art gallery that shows sculpture, paintings, prints, and photographs by local artists along side 400 year-old Chinese scrolls, French bronze sculpture, and Burmese woodcarvings. The local art is for sale and includes Peter Huntoon's watercolors of the castle.

Along Route 4

Art Gallery at the Cortina Inn

103 US Route 4
Killington 05751
(802) 773-3333
www.cortinainn.com
The Gallery is always open.

Ann McFarren curates the ever-changing artwork exhibited in the main lodge and balcony of the Cortina Inn. On the walls around the fire pit, one finds paintings, prints, photography, and sculpture. The work is for sale. Art on view includes Betty Papineau's landscapes, Caroline Shattuck's monotypes, Jeron Fox's watercolors, Margot Hobbs' abstracted landscapes, to name a few. The Cortina Inn is one of the best places to see a diverse selection of art by artists in the Rutland area.

The Barnsider Gallery

24 US Route 4 East (Woodstock Avenue)
Mendon 05701
(802) 775-1508
www.thebarnsidergallery.com
The Gallery is open Monday through Saturday from 10 a.m. to 6 p.m. and on Sunday from 11 a.m. to 4 p.m.

Americana painter Michael Fratrich is the main focus of this four-room gallery on Route 4 just outside of Rutland. The original oils and prints "celebrate the character, history, and mood of our region's vintage era." Medana Gabbard's folk art is also on view.

Carving Studio & Sculpture Center

259 Marble Street
West Rutland 05777
(802) 438-2097
www.carvingstudio.org
The Gallery is open Saturdays and Sundays from 1 to 4 p.m. and by appointment.

Situated among abandoned marble quarries, the Carving Studio is one of the best places for sculpture in Vermont. Established in 1987, the Carving Studio offers workshops, artist residences, public demonstrations, and exhibitions of sculpture in a variety of media. Each year, from late summer to early fall, the Carving Studio presents Sculptfest.

The gallery and workshop room shows wood and stone-carved sculpture as well as large photographs of the quarry. The small field littered with large marble, granite, and metal sculpture across from the main building makes for a great picnic spot.

Farrow Gallery and Studios

835 Main Street (Route 4A)
Castleton 05735
(802) 468-5683
www.vermontel.net/~farogal/
The Gallery is open daily, except Tuesday, from 10 a.m. to 5 p.m. It's best to call ahead in winter.

Nationally recognized sculptor Patrick Farrow lives, works, and exhibits in a converted church on Main Street in Castleton. Farrow creates kinetic, figurative bronze sculptures. Two of his public art installations can be seen in the area: *Frisbee* n front of the McCullough Student Center at Middlebury College and *The Leash* at Depot Park in downtown Rutland. At Farrow Gallery in Castleton, small- and medium-sized work is available, as is paintings by his wife Susan Farrow, and watercolors by Deborah Holmes.

The Christine Price Gallery

Castleton State College
86 Seminary Street (off of Route 4A)
Castleton 05735
(802) 468-1266
www.castleton.edu
The Gallery is open daily during the academic year from 8:30 a.m. to 9 p.m.

The Christine Price Galleryis located in Castleton State's Fine Arts Center.
Exhibitions of varying media change every few months.

Bentley Avenue Fine Art

202 Bentley Avenue
Poultney 05764
(802) 287-5295
www.andreworr.com
Open by appointment or chance.

Bentley Avenue Fine Art is located in an 1860s home in the small village of
Poultney. Poultney is a charming village, home to Green Mountain College
and contains all of those elements that make for a quintessential, small New
England town. Andrew Orr combines impressionism and touches of realism
to create paintings that reflect his love of nature and beauty. His paintings are
"direct and rich, with clear color, expressing his passion for light and life."
Andrew offers seminars at Bentley Avenue Fine Art each autumn.

William Feick Arts Center

Green Mountain College
1 College Circle (at the end of Main Street)
Poultney 05764
(802) 287-8000
www.greenmtn.edu/feick_center/index.asp
The gallery is open Monday through Friday from 12 noon to 5 p.m., except
during college breaks.

Green Mountain College is a private, liberal arts college with a strong environ-
mental focus. The William Feick Arts Center has exhibitions of art.

Events in Rutland County

AUGUST AND OCTOBER
Art in the Park Fine Art and Craft Festivals, Chaffee Center for the Visual Arts, Rutland
Main Street Park
(802) 775-8863
www.chaffeeartcenter.org/aip.htm
2006 will be the 45th year for the festivals, which are held in August and October. Each festival features fine artists and craftspersons, musical entertainment, food, and special art and craft events for children. Both shows are held rain or shine in Main Street Park. Art in the Park was voted one of "Vermont's Top Ten Events" in 2001 by the Vermont Chamber of Commerce and named one of the "2002 Sunshine Artist 200 Best."

AUGUST
East Poultney Day, East Poultney
The Green on Main Street
Held in August each year. The Poultney Area Artists Guild exhibits and sells original artwork. In 2005, East Poultney Day included an 18th century schoolmaster teaching class at the 1791 Union Academy while a British Army Regular disturbed the peace with occasional musket fire.

SEPTEMBER-OCTOBER
SculptFest Exhibition, Carving Studio and Sculpture Center, West Rutland
259 Marble Street
(802) 438-2097
www.carvingstudio.org
This annual event, held each fall, presents large-scale, outdoor installations. An invited curator selects the works on display.

SOUTHWEST VERMONT

Pawlet ◆ Dorset ◆ Manchester
Arlington ◆ Bennington

Pawlet, in the northwestern corner of Bennington County, and Dorset, just north of Manchester along Route 30, have few venues for art. However, Indian Hill Gallery of Fine Photography in Pawlet is definitely worth a visit.

For a town with nearly 100 years of art history, Manchester has fewer and fewer art venues each year but the town's long history of supporting and celebrating the arts continues. The Southern Vermont Arts Center dominates the scene, offering ten solo exhibitions a month and a host of other events and traveling exhibitions. The Artist Guild of Manchester has a signficant gallery space just outside of town. Traditional, for-profit galleries, Tilting at Windmills and Gallery North Star, offer high-end work by established, regional and national artists.

Arlington, between Manchester and Bennington on Route 7A, is home to the Norman Rockwell Exhibition. Rockwell lived in Arlington from 1939 to 1953 and used townspeople as models for some of his work.

At the extreme southwestern corner of Vermont, Bennington is home to the Bennington Battle Monument and the definitive Grandma Moses collection at the Bennington Museum. Downtown Bennington is a hot bed of performing and visual arts events in the spring and summer.

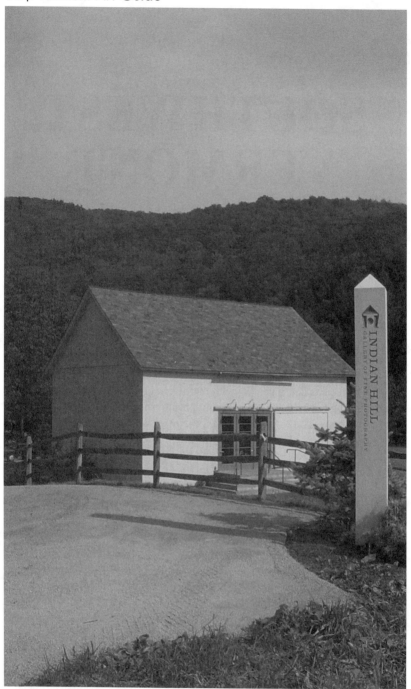

Indian Hill Gallery of Fine Photography in Pawlet.

Pawlet

Indian Hill Gallery of Fine Photography

671 River Road
Pawlet 05761
(802) 325-2274
www.indianhillgallery.com
The Gallery is open May through February on Saturday, Sunday and holiday
Mondays from 10 a.m. to 5 p.m.; on weekdays by chance and by appointment.
The Gallery is open in March and April by appointment only.

The Indian Hill gallery showcases the work of established and emerging
artists working in the photographic medium to engage, provoke, entertain and
inform. Specializing in archival quality, limited-edition photographic prints,
Indian Hill Gallery provides unique opportunities for collecting and a rich
resource for learning about all aspects of photography.

Located in the Mettowee Valley, their state-of-the-art facility is housed in an
exquisitely restored, nineteenth-century, post and beam barn and features rotat-
ing exhibitions and solo shows on three levels. Indian Hill Gallery is also the
home of Stephen M. Schaub Photography. Visitors to the gallery can observe
his studio and learn more about every aspect of the photographic process,
including opportunities for private-study and travel workshops.

Roz Compain Contemporary Stone Sculpture

427 Forrest Farm Road
Pawlet 05761
(802) 325-3431 - fax (802) 325-3829
Ms. Compain's studio is open daily from 9 a.m. to 5 p.m. or by appointment.

Rosalind Compain is known for her direct carving in stone and wood. Her
special rapport with the color, texture and graining of the materials evokes
the forces of nature, powerful yet gentle. Though most of her work is in the
homes of private collectors, some Carrara marble sculptures as high as fifteen
feet adorn the lobbies of office buildings. Museums, universities and galleries
throughout the country have exhibited her carvings.

Dorset

Gallery on the Marsh

2237 Route 30
Dorset 05251
(802) 867-5565
The Gallery is generally open 10 a.m. and 6 p.m. It's a good idea to call ahead.

If the flag is out, this gallery on Route 30 is open. On view is the remarkably detailed wildlife and nature painting of John Pitcher and Sue Westin. The back deck of the gallery over looks a wetland. A diverse painter who works primarily in oil, Sue paints animals, wildlife, landscapes, still lifes, boat scenes, and portraits. John, the consummate naturalist, uses his field journals to inform the details of his final work. This husband and wife team has been in Dorset since 1996.

Manchester

Artists Guild of Manchester

Farmhouse at Manchester Marketplace
1101 Depot Street (Routes 11 and 30)
Manchester Center 05255
(802) 362-4450
www.artistsguildgallery.com
The Gallery is open daily from 9 a.m. to 6 p.m. and Sunday from
10 a.m. to 6 p.m.

Located in a big yellow building next to the Orvis Sale Room on Vermont
Routes 11 and 30, the Artists Guild of Manchester shows work by its members. Some of the work on view at the Guild includes Marilyn Parker's
oil paintings of Vermont and the New England Coast; Folk Artist Martha
Stevenson's paintings; watercolors by Peter Jeziorski and Peter Huntoon's
watercolors; Ann Coleman's brilliant pastel landscapes; and photographs by
Ted Schiffman and Vincent Drew. Many of the artists also have prints of their
work for sale.

Gallery North Star

3962 Main Street (Route 7A)
Manchester Village 05254
(802) 362-4541
www.gallerynorthstar.com
The Gallery is open daily from 11 a.m. to 5 p.m., Sunday from 11 a.m. to
3 p.m.

One of Vermont's oldest galleries, Gallery North Star shows a number of
nationally recognized Vermont painters and sculptors at their Manchester
Village and Stratton Mountain locations. In 2000, Stuart and Nancy Revo
purchased the Gallery and moved it to its present location, a National Historic
Register building on Route 7A. They represent a number of artists including
realist painter Altoon Sultan, landscape artist Paul Stone, Julie Y. Baker
Albright, sculptor Eric Boyer, and oil painter Petria Mitchell.

See also Gallery North Star Stratton Village on page 107.

Tilting at Windmills Gallery

24 Highland Avenue (at Depot Street Routes 11 and 30)
Manchester Center 05255
(802) 362-3022
www.tilting.com
The Gallery is open Monday to Saturday, 10 a.m. to 5 p.m. and Sunday from 10 a.m. to 4 p.m.

Tucked in the retail outlets of Manchester, Tilting at Windmills is a spacious, traditional gallery that has lots of still lifes and landscapes by a long list of artists including Elizabeth Torak, Terry Lindsey, Gerald Lubeck, Mark Wilson Meunier, Steven Stroud, and many others.

Tess Brancato Fine Portraiture

5174 Main Street (Route 7A)
Manchester 05254
(802) 362-1334
www.tessbrancato.com
The Studio is open by appointment.

Tess Brancato is a portrait artist whose studio is in a recently constructed barn designed as a studio. She is a student of Burton Silverman and has also been recognized by the Portrait Society of America. Examples of her portraiture are shown in the gallery, as well as some of her landscapes. She works in a variety of media on a variety of surfaces. Tess also teaches classes in the studio.

Frog Hollow Manchester

3566 Main Street (Route 7A Equinox Shops)
Manchester, Vermont
(802) 362-3321
www.froghollow.org
The Gallery is open most days. Call for seasonal hours.

Frog Hollow Manchester is across the street from the historic Equinox Hotel, a four-star resort built in the 1700s. The space here is bright and friendly. See page 63 for a full description of Frog Hollow Vermont State Craft Center.

Spiral Press Café

At Northshire Books
15 Bonnet Street (Junction of Routes 7A and 30)
Manchester Center 05255
(802) 362-9944
www.spiralpresscafe.com
The Café is open daily: Monday, 8 a.m. to 7 p.m., Tuesday through Saturday, 8 a.m. to 9 p.m., Sunday 9 a.m. to 7 p.m.

The art shown at Spiral Press Café is curated by Nancy Price. Information about her gallery and the artists she represents can be found on page 108.

Museum of the Creative Process at the Wilburton Inn

3814 Main Street
Manchester 05254
(802) 362-0557
www.wilburton.com
Closed on Mondays.

The brainchild of Greek-born psychiatrist Albert Levis, The Museum of the Creative Process promotes "a paradigm shift in art interpretation, from art to science" in which art is presented as a form of conflict resolution. There are four galleries: A Gorski Retrospective, a sculpture trail, the Murals of the Sanctuary of Wisdom, and the Twelve Panels of the Wizard of Oz. Visitors should be prepared for an engaging dialogue about the role art plays in the human experience.

Southern Vermont Arts Center in Manchester.

Southern Vermont Arts Center

West Road
Manchester 05254
(802) 362-1405
www.svac.org
The center is open Tuesday through Saturday, 10 a.m. to 5 p.m., Sunday 12 noon to 5 p.m.

In 1924, Francis Dixon and Frank V. Vanderhoof organized an exhibition of paintings of southern Vermont artists at the Equinox Pavilion in Manchester. The event was a success and they decided to do it again. Eighty-one years later their legacy continues as the Southern Vermont Arts Center, a formidable estate of visual and performing art. SVAC boasts a museum of 19th and 20th century art, a 400-seat performance space, the Garden Café, a sculpture garden, and Yester House, a twenty-eight-room Gregorian Revival mansion that houses ten art galleries dedicated to contemporary artists.

Each summer, the Center's season begins with the Annual Members' Show. Since its inception, inclusion in this exhibit was considered so vital to so many artists' careers that they would move to Vermont to qualify for entry. The show includes paintings, sculpture, photography, and mixed media pieces. After the Members' Show, the Center exhibits approximately ten solo shows each month at Yester House.

Southern Vermont Arts Center publishes an annual catalog of exhibitions that can be found at the Information Center in Manchester or at SVAC.

Arlington

Studio Tansu

39 School Street
Arlington 05250
(802) 375-6808
www.studiotansu.com
The Studio is open Thursday to Sunday, 10 a.m. to 5 p.m. or by appointment

Studio Tansu is the gallery and working studios of Arts and Craft and Asian-influenced John Sutton and watercolorist and children's book writer Leyla Torres. On view is an assortment of furniture, hand-turned bowls and cups, lanterns, ceramics, and fine art.

Lee Arrington Fine Art

3602 West Sandgate Road
Sandgate 05250
(802) 375-9255
www.leearrington.com
Mr. Arrington's studio is open by appointment only.

Lee Arrington Fine Art was established in 2002. Arrington composes work inspired from personal experience and threaded with icons and archetypes that everyone can relate to. A dominant feature is blended with a kaleidoscope of subordinate elements to reinforce the main theme in each composition.

Arrington believes in the healing power of art and has been driven over the past three years to create a body of work that dynamically expresses the universal stories that resonate in all of our lives. Passion, emotion and truth- and the courage to share one's own personal story define Arrington's path of self-expression and the pursuit of a dream.

Bennington

Bennington Center for the Natural and Cultural Arts

Vermont Route 9 at Gypsy Lane
Bennington 05201
(802) 442-7158
www.benningtoncenterforthearts.org
The Center is open Tuesday to Sunday, 10 a.m. to 5 p.m., May until Christmas.
Open Weekends in winter. There is an admission fee for this venue.

The sprawling complex that makes up the Bennington Center for the Natural
and Cultural Arts includes outdoor sculptures, a 315-seat theater, a covered
bridge museum, and six galleries that show Native American arts, master bird
carvings, the Center's permanent collection of natural art, and temporary and
traveling exhibitions. Contemporary art exhibits include solo and juried shows
by local and national artists. Artist Lyman Whitaker's kinetic wind sculptures
can be seen on the grounds as well as a slate stone circle reminiscent of
Stonehenge.

Bennington Arts Guild

215 South Street (Route 7 at the corner of Elm Street)
Bennington 05201
(802) 442-5758
www.benningtonartsguild.com
The Gallery is open daily from 10 a.m. to 4 p.m. and Sunday from 11 a.m.
to 2 p.m.

The Bennington Arts Guild is a cooperative organization that promotes local
arts and craft. They operate a gallery which is located in the Historic Black-
smith's Shop that also houses the Better Bennington Corporation's Welcome
Center. Juried work is on exhibit and includes fine art by local, regional artists
and craft.

Fiddlehead at Four Corners in Bennington.

Fiddlehead at Four Corners

338 Main Street (at junction of Routes 7 and 9)
Bennington 05201
(802) 447-1000
Fiddlehead is open daily, except Wednesday, from 10 a.m. to 5 p.m; and
Sunday 11 a.m. to 3 p.m.

In 2000, Joel and Nina Lentzner opened Fiddleheads at Four Corners in an old
bank building at the intersection of Routes 7 and 9. A cross between a fine
craft store and a gallery, Fiddleheads offers art from all over the United States
and some local artists as well. In addition to fine art, prints, and photography,
a nice selection of glass, pottery, and sculptural objects are on hand. For sale
is work by self-taught artist James Dean whose fun, funky work features a
blue Pete-the-Cat, Shaftsbury nature photographer John Carver, and Graham
Davidson's three-dimensional paper work in painted poplar frames.

Suzanne Lemberg Usdan Gallery

at Bennington College
1 College Drive
Bennington 05201
(802) 440-4743
www.bennington.edu
The Gallery is open when there is a show installed from Tuesday to Saturday
from 1 to 5 p.m. Closed on all college holidays.

Housed in the Visual and Performing Arts Center, the Usdan Gallery is mod-
eled after the fourth floor of the Whitney Museum of American Art in New
York City. Exhibits show work by guest artists, faculty members, and students.

Integrative Therapies Center

At Southwestern Vermont Health Care, Medical Arts Building
140 Hospital Drive, Suite 215
Bennington 05201
(802) 442-1291

The Bennington Arts Guild organizes rotating shows of local artists at this
health center.

Corridor Art Gallery

At Southwestern Vermont Medical Center
100 Hospital Drive
Bennington 05201
(802) 442-3010
www.svhealthcare.org

The Corridor Art Gallery at Southwestern Vermont Medical Center shows art work by local artists, schools, and non-profits. It is open to all mediums. Art is displayed in cases in a corridor on the first floor. From the lobby, follow signs to Administration or ask at the Information Desk. Art is for sale through the gift shop. Exhibits change every six to eight weeks. The Corridor Art Gallery started in 1974.

Outside of the Corridor Art Gallery, the hospital's unique collection of art work can be seen in hallways, lobbies, and waiting rooms. Almost since its beginning in 1913, artists from the surrounding area have given paintings and other forms of artwork to the hospital. Many people donated because of the care they received while they or a loved one was at the hospital. A volunteer committee is currently documenting the collection. Some highlights include a number of paintings from the 1930s by Harriet Miller.

ART AND FOOD

South Street Café

105 South Street
Bennington 05201
(802) 447-2433

A large, airy space with outdoor tables in summer, South Street Café offers espresso drinks and baked goods. Ongoing exhibits of visual arts are on display.

Izabella's Eatery

351 Main Street
Bennington 05201
(802) 447-4949

Serving breakfast and lunch, Izabella's shows works by Bennington-area artists on its brightly painted walls.

Bennington Museum

75 Main Street (Route 9)
Bennington 05201
(802) 447-1571
www.benningtonmuseum.org
The museum is open daily, 10 a.m. to 5 p.m. Closed Wednesdays
There is an admission fee for this venue.

Amidst the 18th century furniture exhibits, 19th century portraits, and early 20th century art glass at the Bennington Museum is a delicious sample of art from this century. Bennington Museum, renowned for its collection of American folk art and regional historical artifacts, has taken on a somewhat ambitious task of promoting contemporary artists from around the region.

Since 1928, the museum has been housed is a converted Roman Catholic Church. In 1972, they acquired the one-room schoolhouse attended by Grandma Moses and members of her family to supplement their extensive collection of her work. But for those who believe historical museums don't usually excel at the promotion of contemporary art, the Bennington Museum proves them wrong.

Since the fall of 2003, the Museum has dedicated its South Corridor Gallery to showcasing local, contemporary artists. To date, they have shown the "lusciously serious" small works of Pat Adams; Sally Apfelbaum's vibrant flower photography; and Jose Sacaridiz's colorful collages. Museum staff curates these exhibitions, which, if past shows are any indication, promises to be worth the trip.

Events in Southwest Vermont

MAY AND JULY-OCTOBER
Funky Friday, Bennington
Downtown Bennington
(802) 447-3311
www.bennington.com/attractions/events/funkyfriday.html
On the second Friday of May, July, August, September and October from
5 to 8 p.m., downtown Bennington and participating merchants provide an
opportunity to experience visual and performance art in a variety of settings.
Look for signs designating participating Funky Friday merchants.

MAY
Mayfest, Bennington
Main Street, Downtown
(802) 442-5758
www.bennington.com/bbc/mayfest.html
For the Saturday of Memorial Day Weekend, Main Street in historic Down-
town Bennington is transformed into Mayfest. Visit booths of over 100 artists,
artisans, craftspeople and food vendors.

JUNE
JuneARTS! Celebration, Bennington
Downtown Bennington
(802) 442-5758
www.bennington.com/bbc/june_arts.html
For three weekends in June, downtown Bennington is full of a wide variety of
music, art, dance, and street performances.

AUGUST
Southern Vermont Art and Craft Festival, Manchester
Hildene Meadows, south of Manchester on Route 7A
www.craftproducers.com/festivals/hildene.htm
Held each August, the Southern Vermont Art and Craft Festival brings together
175 fine artists and craftspeople from around the country. Live entertainment is
provided and a food court has diverse offerings.

OCTOBER
Hildene Foliage Art and Craft Festival, Manchester
Hildene Meadows, south of Manchester on Route 7A
www.craftproducers.com/festivals/fall-hildene.htm
Late September and Early October is the height of foliage season. This art and
craft festival, located at Hildene, Robert Todd Lincoln's summer home, brings
together 180 artists and craftspeople in heated tents. Items for sale include
original art and photography, home furnishings, jewelry and clothing. Fresh
food and live entertainment will also be offered.

ROUTE 100

South ◆ Central ◆ Stowe ◆ North

Few states can boast of a road as remarkable as Route 100. From Massachusetts to the Canadian border, Route 100 snakes along rivers, though mountain valleys, and into farmland. Along the way, small towns with village greens and country stores dot the landscape. Route 100 also offers one of the richest corridoors for art in the state.

Organized here from South to North, venues not directly on Route 100 are a short, worthwhile detour.

South is from the Massachusetts border to Route 4, Central is from Route 4 to Stowe, which is its own section, and venues north of Stowe make up the last section.

Stowe is also the home of Stowe Studio Arts which organizes exhibits of local artists at a number of venues in Stowe. Artist Carol Drury produces the *Stowe Gallery Guide*, which does a good job of listing almost all of the venues in Stowe. The Guide is available at the Stowe Visitor's Center and all over town.

South

Ann Coleman

437 Maple Drive
Whitingham 05361
(802) 368-7090 - fax (802) 368-2647
www.artistanncoleman.com
Ms. Coleman's studio is open from 9 a.m. to 9 p.m., but please call ahead first.

A student of art from an early age, Ann Coleman did her degree work at Salzburg College, Austria, the Salzburg Art Academy and Skidmore College where she received a BS in Studio Art. Since that time Coleman has focused primarily on watercolors and pastels; her works have been displayed throughout the northeastern U.S. In Whitingham, Coleman indulges in other passions: skiing, sailing and flower gardening, which show up as subjects of her paintings. Her works include an array of finely detailed portraitures done in watercolor and pastels. Coleman is always open to discussing new ideas for commissioned works.

The Jimmy Shack

30-B West Main Street (behind the Norton House) (Route 9)
Wilmington 05363
(802) 464-3020
www.thejimmyshack.com
The gallery is open Thursday from 2 to 6 p.m.; Friday through Sunday from 10:30 a.m. to 7 p.m.; Monday from 10 a.m. to 3 p.m.; and by appointment.

The Jimmy Shack is in a small, black building with a yellow sign: Jimmy Shack-a collection of all things cool. The gallery features shows by local artists and sells photography, furniture, and functional art.

Quaigh Design Centre

11 West Main Street (across from Memorial Hall, Route 9)
Wilmington 05363
(802) 464-2780
The Centre is open July through October daily from 11 a.m. to 5:30 p.m. Call ahead for hours during the rest of the year.

This craft and home décor shop also carries English cottage prints by Victoria Elbrock and prints and paintings of Vermont farms by Mary Azarian. The gallery space is on the second floor.

Gallery Wright: Sticks & Stones Studio

7 North Main Street (Route 100)
Wilmington 05363
(802) 464-9922
www.gallerywright.com
The Gallery is open daily from 11 a.m. to 5 p.m. with extended evening and weekend hours. Appointments are welcome.

This is a professional, storefront fine art and craft gallery in Wilmington's village center next to Maple Leaf Malt and Brewing. Gallery Wright specialises in contemporary realism, landscape, figurative and still life painting. Included in the gallery is work by sculptural crafters and art jewelers. The working metal studio of gallery director Marie Therese Wright is on premise. The artists represented by the gallery include Patricia Carrigan, David Brewster, and Caroline Jasper. Monthly exhibits highlight the work of a different artist.

Gallery North Star Stratton Village

761 Mountain Road
West Wardsboro 05360
(802) 297-3400
www.gallerynorthstar.com
The Gallery is open daily during the winter season, otherwise on selected weekends only.

Gallery North Star in Stratton Village Square is a branch of Gallery North Star in Manchester, which is owned by Stuart and Nancy Revo. See Gallery North Star Manchester on page 93 for more information.

Nancy Price Gallery

In Jamaica Village on Routes 30 and 100
Jamaica 05343
(802) 874-4489
www.nancypricegallery.com
The Gallery is open Wednesday through Monday from 10 a.m. to 6 p.m. and
by appointment.

The focus of the Gallery is fine art photography, but the Gallery also represents
internationally exhibited and local painters and sculptors. The Gallery space
is in an 1830s Federal style house in Jamaica village and shows the work of
over 30 artists. Among the featured artists on display are photographers Robert
Reichert, James Duval, Les Jörgensen, M.M. Battelle, and Douglas Biklen.
Price also curates for the Spiral Press Café in Manchester, the Three Mountain
Inn in Jamaica, Max's Restaurant in Brattleboro, and the Latchis Theater in
Brattleboro. Rotating exhibits are announced throughout the local papers and
on the gallery's website.

Elaine Beckwith Gallery

3923 Vermont Route 30 (Routes 30 and 100)
Jamaica 05343
(802) 874-7234
www.beckwithgallery.com
The Gallery is open from 10 a.m. to 5:30 p.m. and is closed on Tuesday.

The Elaine Beckwith Gallery represents 30 mid-career artists from Vermont
and the U.S. whom the gallery represents exclusively in Southern Vermont.
The gallery space itself has on-going exhibitions of all of the artists repre-
sented. The collection is diverse. The work is both traditional and abstract, but
tends to the representational with much figurative work, including architectural
painting and still lifes. About one-third of the artists are from Vermont. The
gallery has a large number of etchings, especially the work of Joel Beckwith,
the gallery's Artist in Residence. Other artists represented include painters
Barbara Coburn, James Grabowski, Miriam Adams, and Janet McKenzie,
whose painting *Jesus of the People* was selected by Sister Wendy Beckett
for the *National Catholic Reporter's* Jesus 2000 competition. Sculptor Ray
Perry's whimsical *Sir* greets the visitor upon entering the gallery.

The Garden Café and Gallery
Routes 11 and 100
Londonderry 05148
(802) 824-9574
The Café is open for dinner and Sunday brunch.

Art is everywhere at the Garden, with almost 3,000 square feet of space. The dining area is on the ground floor with gallery space in the hallways and up on the second floor, which is a well-lit, multi-level space. Many contemporary artists are represented, including John Paulus Semple, who is exclusively represented by the Garden. Near the dining area, on the ground floor, look for a niche containing a large painting of President Clinton and Monica Lewinsky. Quite unexpected!

Todd Gallery
614 Main Street (Route 100)
Weston 05161
(802) 824-5606
www.toddgallery.com
The Gallery is open Thursday to Monday from 10 a.m. to 5 p.m.

The Todd Gallery is a two-story space on the southern edge of the "quintessential Vermont village" of Weston. The gallery showcases the work of Robert E. Todd, who founded the gallery with his wife, Karin, in 1986. Todd paints landscapes of Vermont and Ireland and agricultural scenes in original oils and limited edition giclee prints. The large second floor gallery shows work by Burlington watercolorist Annelein Beukenkamp and photographer Allistair McCallum. Todd Gallery is unique in presenting the remaining abstract serigraphs of Edward Landon (1911-1984). Landon was a pioneer in the development of serigraphy in the 1950s and 1960s and introduced the technique to Europe.

Robert Sydorowich Studio

4219 East Hill Road
Andover (Ludlow) 05149
(802) 875-3154
www.robertsydorowich.com
Please call ahead for studio hours.

Robert Sydorowich paints the Vermont countryside, where he has lived for over forty years. He works in the transparent watercolor media style. Reminiscent of the impressionist movement, Sydorowich's work portrays "real places, real people, real life situations.

Lavender Hill Studio and Gallery

1152 Howard Hill Road
Andover (Chester) 05143
(802) 875-4380
The Studio and Gallery are open Friday through Sunday from 10 a.m. to 5 p.m. On other days, please call first.

Visitors to Martha Lavender Nichols' studio and gallery will see landscapes of Pennsylvania and Vermont in oils, pastels, and charcoal, which vary in size from images to large scale oils.

Hunter Lea Gallery and Frame Shop

119 Main Street (Route 103)
Ludlow 05149
(802) 228-4703
www.hunterleagallery.com
The Gallery's hours vary by the season, but is always open Saturday (10 a.m. to 6 p.m.) and Sunday (10 a.m. to 5 p.m.) and is always closed on Wednesday.

Hunter Lea Gallery is located in the heart of Ludlow in a large, yellow Victorian house. Artists from all over New England have work on display-paintings, prints, and giclee, including David Merrill, Leslie Miller, Peter Huntoon, and Sabra Field. These works are generally of rural life. The gallery also has a smaller collection of abstract works by such artists as W. Nye, J.D. Karam, and T.L. Lange.

Black River Gallery at Hawk Inn and Mountain Resort

Located between the two buildings of the Hawk Inn
2½ miles South of Plymouth on Route 100
Plymouth 05056
(802) 672-3811
www.hawkresort.com/attractions/blackrivergal.html

The Black River Gallery presents paintings and photographs in a building overlooking a bend in the Black River. The art on display interprets the Vermont landscape. Many of the artists are Vermonters and others hail from Maryland and Massachusetts.

Central

BigTown Gallery

99 North Main Street (Route 100)
Rochester 05767
(802) 767-4231
The Gallery is open Wednesday through Saturday from 10 a.m. to 5 p.m.;
Sunday from 11 a.m. to 4 p.m.; or by appointment.

BigTown Gallery opened to much fanfare in 2003. The distinctive building is
recognizable by the large, Asian-inspired round entryway. The art on display is
by local and regional artists and is eclectic.

ART AND FOOD

Rochester Café and Country Store

Main Street (Route 100)
Rochester 05767
(802) 767-4302

The café, serving breakfast and lunch, has one of Vermont's last remaining
soda fountains. So enjoy a root beer float while taking in art by local artists.

Parade Gallery

270 Main Street (Route 100)
Warren 05672
(802) 496-5445
www.paradegallery.com
The Gallery is open from 10 a.m. to 5:30 p.m. daily and is closed only on
Wednesday.

Since 1982, Parade Gallery has offered affordable original and reproduction
artwork in all mediums including sculpture, concentrating on established and
emerging Vermont artists while including regional artists. This small frame
shop and art gallery has a selection of prints and original work, including
Bonnie Acker's oil pastels and oil on paper, Kathleen Kolb's watercolors,
prints by J.D. Logan and Will Moses, as well as Rourke Sharlow's hand-
colored photographs.

Artisans' Gallery

Bridge Street, Waitsfield Village (just off of Route 100)
Waitsfield 05673
(802) 496-6256
www.vtartisansgallery.com
The Gallery is open daily from 10 a.m. to 5 p.m.

One hundred and fifteen artists show their work at the Artisans' Gallery in historic Waitsfield Village. The collection is housed in the historic Jones Building and is steps away from a covered bridge built in 1833. The work on display is a blend of traditional and contemporary in a variety of media. The work is selected through a monthly jury of the seven artists/owners. The core artists of the gallery represent craft and fine art: Peggy Potter (wooden bowls), Biffie Gallant (Stained Glass), Macy Moulton (linoleum block prints), Michael McKenna (lamps), Lori Klein (jewelry), Janii Peterson (weaving-clothes, shawls, scarves). Among the visual artists on display are Candy Barr, Sean Callaghan, Dennis Curran, Beth Kendrick, and Dennis Sparling.

Bundy Center for the Arts

Bundy Road (dirt), off of Route 100, south of Waitsfield village about 2.3 miles past junction of Routes 17 and 100
Waitsfield 05673
(802) 496-4781
www.bundycfa.org
The Gallery at the Bundy is open Friday from 4 to 7 p.m. and Saturday and Sunday from 1 to 4 p.m.

The Bundy was constructed in 1962 in a Bauhaus style. It was renovated and updated in 2004. The Gallery is constantly rotating its exhibits of locally and internationally known artists. The Center also hosts classical chamber music, jazz and children's concerts. The Center also holds workshops and clinics on a variety of arts topics for both children and adults, including watercolor and pastels, filmmaking, digital media, acting, musical theater, jazz and more.

Gold Leaf Gallery

Route 100, Village Center
Waitsfield 05673
(802) 279-3824
www.goldleaf-gallery.com
The Gallery is open Wednesday and Thursday from 10 a.m. to 5 p.m.;
Saturday and Sunday from 11 a.m. to 5 p.m.; and by appointment.

Gold Leaf Gallery specializes in presenting "quality contemporary paintings that reflect the New England experience." Gallery owner Kenneth Ochab exhibits his own work, which includes the Mandala Nouveau series. These paintings combine Buddhist mandala forms originating in the 12th century and Art Nouveau that reached its peak around 1900. Among the contemporary artists represented is Gertrude Belloso, who creates small oils, and Jean Cannon, who lives in Burlington, and whose style "is based on keen draftsmanship… and leans toward the surreal."

Northern Power Systems

182 Mad River Park (off of Airport Road, about 2 miles south of junction of Routes 100 and 100B)
Waitsfield 05673
(802) 496-2955 x352
www.northernpower.com
The office is open Monday through Friday from 8 a.m. to 5 p.m.

Northern Power Systems designs, builds and installs electric power systems for a variety of customers. Art by local artists is shown. Once a year there is a show of art by employees and their families. The art is displayed in the lobby and on the second floor balcony, which takes advantage of the high ceilings and window light. The shows are generally of one artist and are changed every couple of months. The show slots are filled by a committee of four employees and each show has an opening reception, which is announced in *Seven Days*. The shows are informal and visitors are welcome. The art is displayed in a working office environment and visitors should be respectful of that.

Stowe

West Branch Gallery
& Sculpture Park

17 Towne Farm Lane (off of Route 108, behnd the Rusty Nail)
Stowe 05672
(802) 253-8943
www.westbranchgallery.com
The Gallery is open daily from 11 a.m. to 6 p.m.

West Branch is owned by sculptor Chris Curtis and painter Tari Swenson. The gallery represents over 30 active artists from around the country. New exhibits of work are shown every two months with half the gallery space devoted to solo work. The sculpture park has paths that wind down to the Waterbury River. One of the sculptures is actually in the river. The art represented includes oils on paper by Don Hanson, encaustic and oils by Holly Hauser, metal sculpture by John Matusz, and stone sculpture by Ikram Kabbaj.

Clarke Galleries

618 South Main Street (Route 100)
Stowe 05672
(802) 253-7116
www.clarkegalleries.com
The Gallery is open seven days a week, appointments are recommended.

Clarke Galleries is housed in two buildings. The main gallery is in a turn-of-the-20th century loft building in Stowe village. The annex, called Clarke Fine Art at Cold Comfort Farm, is in a circa 1850s barn on West Hill Road that is open by appointment only. The collection specializes in 19th and 20th century American and European art. Vermont artists represented include contemporary artists such as Cynthia Price, Altoon Sultan, and Robert Cardinal and classic Vermont artists such as Emile Gruppé and Luigi Lucioni. Many landscapes of both Vermont and elsewhere are available. There is also a large selection of bird art including work by John James Audubon and sculptor Bert Brent.

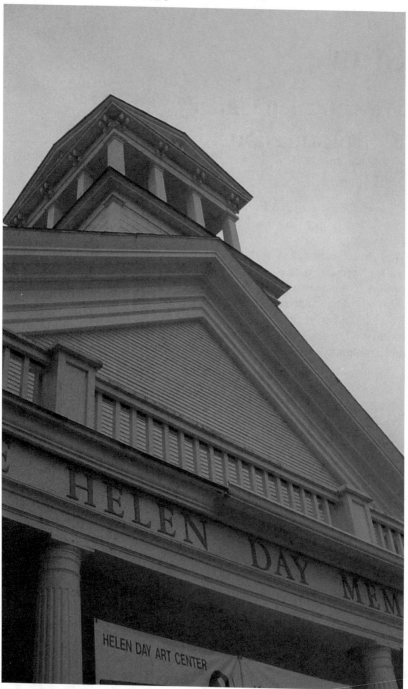

Helen Day Art Center in Stowe.

Helen Day Art Center

School Street
Stowe 05672
(802) 253-8358
www.helenday.com
The center is open in winter, Tuesday through Saturday from 12 noon to 5 p.m. and in summer, Tuesday through Sunday from 12 noon to 5 p.m.

Helen Day Art Center (HDAC) has been called one of the best places to see art in Vermont. Located on School Street on the second floor of a 1856 Greek Revival building that once housed Stowe High School, HDAC sports three galleries. The East Gallery generally showcases one Vermont artist. The two main galleries show a variety of work, from cutting edge contemporary to student shows.

Every exhibit has a family day and guest artist workshops. Other programs at HDAC include films, lectures, and workshops. Docents are well informed and accessible.

Robert Paul Galleries

394 Mountain Road (Route 108)
Stowe 05672
(802) 253-7282
www.robertpaulgalleries.com
The Gallery is open Monday through Saturday from 10 a.m. to 6 p.m. and Sunday from 10 a.m. to 5 p.m.

The Galleries offer a selection of original paintings, sculpture, photographs, and graphics, as well as custom framing. The genres of work range from classic realism to contemporary. Among the featured work is Javier Mulio's photorealistic still lifes in oil on panel; Don Landwehrle's photographs of the Stowe area; Christine Nesvadbas' large, brilliant florals in oil; prints of work by Fred Swan; and sculpture by Nancy Diefenbach.

The Art Gallery in Stowe
35 South Main Street (Route 100, next to the ski museum)
Stowe 05672
(802) 253-6001
www.stoweartgallery.com
The Gallery is open daily except Wednesday, 11 a.m. to 5 p.m.

The Art Gallery is housed on the second floor of a small, yellow house that has a real estate office on the ground floor. Proprietor Lillian Zuber shows her oil paintings. The gallery features the detailed oils of Michael McGovern, Jerry Ralya's figurative pastels, oils by Carroll Jones. Also by Carroll Jones, the gallery sells a video guide to Renaissance painting called Echoes of the Renaissance.

Vermont Fine Art Gallery
Gale Farm Center, 1880 Mountain Road (Route 108)
Stowe 05672
(802) 253-9653
www.vermontfineartgallery.com
The Gallery is open Monday through Saturday from 10:30 a.m. to 5:30 p.m.

The Vermont Fine Art Gallery specializes in work by award-winning Vermont artists, Vermont work by nationally recognized artists, and paintings by gallery owner-artist Elizabeth W. Prior. On display, one can see breathy landscapes in oil by Elizabeth Allen, dreamy still lifes by Alastair Dacey, and plein air work by Gil Perry. Also included are folk artist Gloria Sternthal and abstract artist Denise Cote.

Copley Woodlands Gallery
125 Thomas Lane
Stowe 05672
(802) 253-7200
www.copleywoodlands.com
The Gallery is open Monday to Saturday from 8 a.m. to 4 p.m.

Copley Woodlands is a retirement community just off of South Main Street (Route 100). Shows by local artists are rotated each month.

Inky Dinky Oink, Ink.

117 Adams Mill Road (off of Route 100, south of Stowe village)
Moscow 05662
(802) 253-3046
www.oinkink.com
Inky Dinky Oink is open from June to October, Thursday through Sunday
from 11 a.m. to 5 p.m. or by appointment. It is best to call ahead.

Artist Liz Le Serviget operates Inky Dinky Oink-a studio/gallery, farm stand,
and bed and breakfast-out of a 145-year-old farmhouse about 5 minutes from
Stowe village. Liz "paints everything" and her work is throughout the house
and studio. Her work is fun, whimsical, and folksy and includes painting,
photography, murals, floor paintings, and furniture. Much of her work includes
animal imagery.

New England Framing and Fine Art

1056 Mountain Road (Route 108)
Stowe 05672
(802) 253-5671
New England Framing is open daily, except Sunday and Tuesday, from 10
a.m. to 5 p.m.

New England Framing and Fine Art has a diverse selection of original art.
Featured art includes sculpture and glass by Danish artists Anni Kristine and
Flemming Holm, giclees of work by Luigi Lucioni, acrylic and oil on canvas
by Judith Henderson, and hand-made furniture by members of the Vermont
Furniture Guild. All frames are made in-house.

Milestone Art Studio Gallery

67 Pleasant Street
Stowe 05672
(802) 253-3067
Please call the studio for hours.

Milestone is the studio of Dee Macy. Macy paints in a classic realist/
impressionistic style in oils a la prima. Her subjects are mainly landscapes and
still lifes. She also teaches classes in oil painting.

Green Mountain Fine Art Gallery

64 South Main Street (Route 100)
Stowe 05672
(802) 253-1818
www.greenmountainfineart.com
The Gallery is open daily except Tuesday from 11 a.m. to 6 p.m.

This gallery has a large variety of work from 35 regional artists in a variety of media. On display are small sculptures by Hy Suchman, pastels by Mickey Meyers, colorful abstracts by Dorothy Martinez, oils by Barbara Wagner, and folk art by Nina Riley. The gallery is housed in an historic Federal-style house built in 1828 and is part of Stowe village's National Historic District designation. The gallery recently added a sculpture garden, "The Hidden Garden". The gallery was founded in 2001 and is managed by Sandra Noble and Diane Bruns, who are both art educators. The gallery also showcases its featured artists in the Mozart Room at the Von Trapp Family Lodge in Stowe.

Stowe Inn Gallery

123 Mountain Road (Route 108)
Stowe 05672
(802) 253-4030
www.stoweinn.com

The gallery at the Stowe Inn exhibits the collection of owner Jed Lipski. Much of the work on view is that of local artist Walton Blodgett. Also throughout the inn is an exhibit of Vermont landscapes by Eric Tobin.

Stowe Town Hall

67 Main Street (Route 100)
Stowe 05672
(802) 253-8571
The Town Hall is open Monday to Friday from 9 a.m. to 4 p.m.

Stowe Town Hall is the administrative hub of the Town of Stowe, as well as the home gallery base of Stowe Studio Arts, an organization of artists and patrons of the arts. Group shows by members are given every summer and winter and special shows are given every spring and fall.

ART AND FOOD

Blue Moon Café

35 School Street
Stowe 05672
(802) 253-7006
The Café is open daily from 6 a.m. to 9:30 p.m.

The Blue Moon Café is an art space of Stowe Studio Arts. Local artists are represented and shows rotate frequently.

Restaurant Swisspot

128 Main Street (Route 100)
Stowe 05672
(802) 253-4622

The Restaurant Swisspot had its start as part of the Swiss pavilion at Expo '67 in Montreal. Now located in the heart of Stowe village, the restaurant serves lunch and dinner. Work by a local artist is shown, with exhibits changing every four months.

ART AND MONEY

Union Bank

47 Park Street (at the corner of Pond Street)
Stowe 05672
(802) 253-6600
The bank is open Monday through Thursday from 8:30 a.m. to 4 p.m.; Friday from 8:30 a.m. to 6 p.m.; and Saturday from 9 a.m. to 12 noon.

Works by Stowe-area artists are shown.

North

Jacob Walker Art Gallery

Morristown Corners General Store (off of Stagecoach Road)
Morristown Corners 05661
(802) 522-7191
The Gallery is open six days a week from 11 a.m. to 5 p.m. from late June to mid-October. The Gallery is closed on Tuesday.

The Jacob Walker Art Gallery is seasonal art cooperative with 25 artist members founded in 1993. The gallery was conceived by Jeannette Lepine, owner of the Morristown General Store. Among the original members were Robin Nuse, Lisa Beach, Eric Tobin, Marc Tobias, Jane Desjardins, and Marianne Herlitz. The gallery is named after Jacob Walker, the first recorded settler in Morristown. Artists each have a section of wall space to display their work, and take turns doing the gallery sitting. Many of the artists work on creative projects when they are there and are more than happy to answer questions and share their working practices with the public.

Tegu Gallery

43 Portland Street (in the Tegu Building, Route 100)
Morrisville 05661
(802) 888-1261
www.lamoillecountyplanning.org/tegu_art_gallery.htm
The Gallery is open Monday to Friday from 8 a.m. to 4:30 p.m.

The Tegu Gallery is a program of River Arts, Lamoille County's arts organization. The gallery offers a self-guided tour of Lamoille County artists whose works are rotated on a regular basis.

The Bee's Knees Café

82 Lower Main Street (Route 100)
Morrisville 05661
(802) 888-7889
www.thebeesknees-vt.com
The Café is open Tuesday through Friday 6:30 a.m. to 10 p.m. and Saturday and Sunday from 8 a.m. to 10 p.m.

The Café serves meals using locally grown and organic ingredients. Art by locally and regionally known artists, such as Lois Eby, adorn the walls. Shows are updated monthly.

Copley Hospital Gallery

528 Washington Highway
Morrisville 05661
(802) 888-8302
www.copleyvt.org

The public areas of Copley Hospital display art by local artists. Artists represented in the past have included watercolorist Randy Eckard and sculptor Judith Wrend.

Well of Stars

331 Westphal Road
Lake Elmore 05657
(800) 551-0648 or (802) 888-7074
www.wellofstars.com
The Gallery is usually open Tuesday through Sunday from 10 a.m. to 4 p.m. Call ahead to check.

Well of Stars is the studio-art gallery of artist Dominic Koval. Koval works in painting, sculpture, carved jewelry, pencil and charcoal. His subjects are drawn from nature and include waterfalls, trees, hidden Vermont, horses, forest beings, and figurative work.

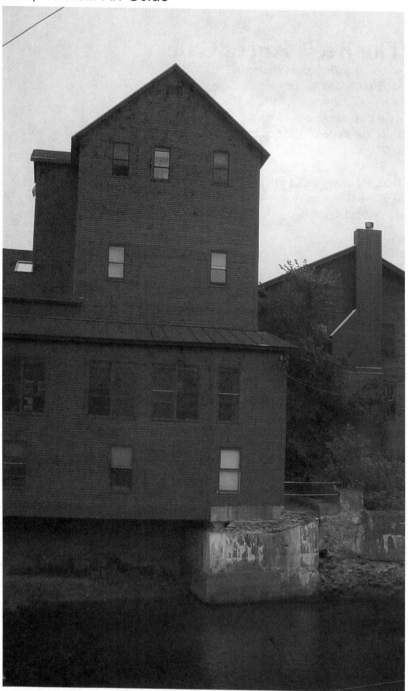

Red Mill Gallery at the Vermont Studio Center in Johnson.

Red Mill Gallery

Vermont Studio Center
80 Pearl Street (off of Main Street, Route 15)
Johnson 05656
(802) 635-2727 - fax (802) 635-2730
www.vermontstudiocenter.org
The Gallery is open daily from 8:30 a.m. to 5:30 p.m.

The Red Mill Gallery is part of the Vermont Studio Center, a non-profit international artists' and writers' creative community and currently the largest colony in the country hosting 600 artists and writers per year (50 per month) in 2-12 week residencies on its 30-building campus. The Red Mill Gallery hosts some 50 shows per year, which includes work by VSC artists, VSC trustees, Johnson Elementary School students, as well as elder artists from Lamoille County. It is supported by foundations and VSC trustees, as well as VSC alumni and others. VSC has been in continuous operation since 1984.

Julian Scott Memorial Gallery

Johnson State College
337 College Hill
Johnson 05656
(802) 635-1469
www.jsc.vsc.edu/resources/139.html
The Gallery is open in the summer Tuesday through Friday from 12 noon to 6 p.m. and Saturday from 12 noon to 4 p.m. Please call for academic year hours.

Julian Scott was a native of Johnson who achieved fame as a painter during the Civil War. His painting *The Battle of Cedar Creek* hangs in the Vermont State House. The gallery named in his honor is on the campus of Johnson State College and features the work of locally- and nationally-recognized artists. Student and faculty exhibits are held throughout the school year.

Bad Girls Café

38 Lower Main Street (Route 15)
Johnson 05656
(802) 635-7423
www.badgirlscafe.net
The Café is open daily from 7 a.m. to 6 p.m.

Besides offering coffee and baked goods, the Bad Girls also offer up a diverse array of art every month. Opening receptions are held and you can see who is on the walls by checking *Seven Days*.

Winslow Art Studio

143 Main Street (Route 108)
Jeffersonville 05464
(802) 644-2644
www.WinslowArtStudio.com
The Studio is open daily, except Monday, from 12 noon to 6 p.m.

Established in 1979, the Winslow Studio has been in its location in Jeffersonville since 2001. Owners John (Jack) and Karen Winslow are highly trained professional painters, who studied with Frank Mason at the Art Students' League in New York. They grind most of their own paints and make their own mediums and varnishes. All paintings are done from life and include landscapes, still lifes, interiors and portraits. The storefront gallery shows Jack and Karen's work and sometimes work by other artists. The studio is also a teaching venue where classes are taught to individuals and groups in the Classical Realist tradition.

Mary & Alden Bryan Memorial Gallery

180 Main Street (Route 108)
Jeffersonville 05464
(802) 644-5100
www.bryanmemorialgallery.org
The Gallery has seasonal hours and is open daily from June to October from
10 a.m. to 5 p.m. Call ahead at other times.

The Bryan Gallery was founded in 1984 by Alden Bryan, who designed the
facility and oversaw its construction. Both Alden and Mary Bryan were paint-
ers who moved to Jeffersonville in 1937. Their legacy is this gallery, which
promotes the work of Vermont and New England artists. There are two main
wings: The West Wing features the art of gallery members. The East Wing
hosts rotating exhibits. Occasionally, the entire gallery is devoted to special
shows, including an annual landscape invitational, a members' show, and a
holiday fair.

Milk Room Gallery and Frame Shop

105 Main Street (Route 108)
Jeffersonville 05464
(802) 644-5122
www.milkroomgallery.com
The Gallery is open Tuesday through Friday from 10 a.m. to 5 p.m. and on
Saturday from 10 a.m. to 3 p.m.

The Milk Room features original work from 35 mainly Vermont artists, with
work in photography, watercolor, pastels and oils. Among the featured art and
artists are Cambridge, Vermont-based Margaret Hobbs who works *en plein air*;
Mark Tougias' New England scenes; and colorful, primitive oil paintings by
Isabeth Hardy. The gallery gets its name from its original location in the milk
room of a dairy barn about five miles outside of town. The gallery's current
location in the center of Jeffersonville is a house built in the 1820s.

Events along Route 100

JULY
River Arts Festival, Morrisville
Throughout Morrisville, Route 100
(802) 888-1261
www.riverartsvt.org
Held in late July, this town-wide event focuses on art outdoors, but also
includes music, children's activities, fire trucks, and more.

JULY
Art on the Mountain Show, West Dover
Sundance Upper Base Lodge, Mount Snow Resort
(802) 423-7535
www.artonthemountain.org
Held late July and early August, the Art on the Mountain Show exhibit
and sale is the main fundraising event for the Deerfield Valley Health Care
Volunteers, who raise funds for health care needs in area towns. Over 200
artists and craftspeople from New England and beyond are represented in this
juried show. In addition, an on-line gallery shows work available for purchase
and the Deerhill Inn (www.deerhillinn.com) in West Dover has seasonally
rotating shows of works by Art on the Mountain artists. In 2005, the suggested
donation for persons over age 12 was $5.00.

JULY-AUGUST
**Arts and Crafts Fairs, Fletcher Farm School for the Arts and Crafts,
Ludlow**
611 Route 103 South
(802) 228-8770
www.fletcherfarmschool.org/craftfestival.asp
The Society of Vermont Craftsmen sponsors two arts and crafts fairs at the
Fletcher Farm School in July and August. Over 100 artists and craftspeople
exhibit pottery, primitives, glass and stained glass, oil and watercolor paint-
ings, carvings, scroll work, jewelry, dried flowers, food, doll clothing, and
much more.

AUGUST
**Annual Photography Exhibit, Green Mountain Cultural Center,
Waitsfield**
Joslyn Round Barn at the Inn at the Round Barn B&B
1661 East Warren Road
(802) 496-7722
www.theroundbarn.com/gmcc.htm
The Green Mountain Cultural Center is a volunteer-staffed non-profit dedi-
cated to the performing and visual arts in the Mad River Valley. Each summer,
the Center presents a five-week photography exhibit. A panel of judges pres-
ents five awards of excellence. Winners are invited to hang their photographs
at the Art in the Round Barn Show in September. No admission fee, but
donations are appreciated at the door.

AUGUST
For Art's Sake and A Taste of Stowe, Stowe
Jackson Arena, Park Street, Stowe Village
(802) 253-8358
www.helenday.org/forartssake.htm
For Art's Sake celebrates its 21st year in 2006. For Art's Sake and A Taste of
Stowe is a fundraiser for the Helen Day Art Center and is held each August
at Stowe's Jackson Arena. In 2005, over 80 artists joined 25 restaurants in a
celebration of food, painting and sculpture.

AUGUST
Vermont Festival of the Arts, Mad River Valley
Towns and Villages of the Mad River Valley (along Route 100)
www.vermontartfest.com
During August, the Mad River Valley hosts more than 100 arts-related events.
Visual arts-related events include an art in the garden tour, amateur artist
day, open studios and galleries and exhibits. In addition, there are literary
workshops, musical performances, dance and culinary arts events.

SEPTEMBER-OCTOBER
Art in the Round Barn, Green Mountain Cultural Center, Waitsfield
Joslyn Round Barn at the Inn at the Round Barn B&B
1661 East Warren Road
(802) 496-7722
www.theroundbarn.com/gmcc.htm
The Green Mountain Cultural Center is a volunteer-staffed non-profit dedi-
cated to the performing and visual arts in the Mad River Valley. In its 14th
year in 2005, Art in the Round Barn is a juried show of New England artists.
The show is open daily (running the last week of September to Columbus
Day/Canadian Thanksgiving weekend) and the art may be purchased on site.

SEPTEMBER
Bromley Country Fair, Peru
Bromley Mountain, 3984 Vermont Route 11
(802) 824-5522
www.bromley.com
In its third year in 2006, the Bromley Country Fair celebrates craft, art, food
and music in late September. In addition to the over 100 artists and artisans,
there is also a pig roast. An admission fee is charged.

OCTOBER
Weston Craft Show, Weston
Weston Playhouse, The Green, Route 100
(802) 824-3576
www.westoncraftshow.com
The Weston Craft Show has been showcasing artists and craftspeople from
around Vermont for over a quarter-century. Funds raised from the show
benefit Weston's Historic Preservation. Held over the Columbus Day/Canadian
Thanksgiving weekend.

OCTOBER
Stowe Foliage Art and Craft Festival, Stowe
Stowe Events Field (Mountain Road/Route 108)
(802) 425-3399
www.craftproducers.com/festivals/fall-stowe.htm
Held over the Friday, Saturday and Sunday of Columbus Day/Canadian
Thanksgiving Weekend, the Stowe Foliage Art and Craft Festival brings
together 175 artists and craftspeople. Works include original art, photography,
pottery, glass, furniture, weaving and clothing. The festival takes place in two
heated tents. An admission fee is charged. Children 12 and under are admitted
for free.

CAPITAL REGION

Montpelier ♦ Vermont Arts Council
Barre ♦ Surrounding Area

The capital region of Vermont is home to many state government buildings and the vibrant downtowns of Montpelier and Barre.

In Montpelier, one will find a progressive community with lots of cafés and businesses exhibiting work by local artists. The T.W. Wood Gallery exhibits an impressive selection of WPA art projects. The city is also home of the Vermont Arts Council which oversees the exhibition of art in state buildings and maintains their own exhibition space at their offices on State Street.

Barre, "the granite capital of the world," is home to some of the best granite carvers on the planet. The Rock of Ages quarry holds tours and the areas cemetaries are full of remarkable carved granite tombstones. In the late 19th and early 20th centuries, stonecutters and craftsmen came from across Europe, French Canada, and the Middle East to work. They brought unique ethic heritages and anarchist and socialist ideals which continue to inform the make-up of the town.

In the hills around Barre and Montpelier are dozens of artists. Recently, a group of them have formed a cooperative gallery space in Plainfield, home of the progressive, alternative Goddard College. Blinking Light Gallery is a welcome addition to the tight-knit community in the village of Plainfield.

Montpelier

Vermont Supreme Court

111 State Street (just to the east of the State Capitol, Route 2)
Montpelier 05609
(802) 828-4784
www.vermontjudiciary.org/Resources/artncourt.htm
The court is open to the public Monday through Friday from 7:45 a.m. to
4:30 p.m.

Justice Marilyn Skoglund curates exhibits showcasing Vermont artists. Expect
to find interesting, accessible work shown in a beautiful setting.

T. W. Wood Gallery

at Vermont College
36 College Street
Montpelier 05602
(802) 828-8743 - fax (802) 828-8645
www.twwoodgallery.org
The Gallery is open Tuesday through Sunday from 12 noon to 4 p.m.

One of Vermont's oldest art galleries, The T.W. Wood Gallery was founded in
1896. As the repository of Vermont's portion of the Federal Works Progress
Administration projects, it has one the largest permanent collections in the
state. This work can regularly be seen in the T.W. Wood Room. They also
exhibit work by local artists in their Main and South Galleries.

William Whalen Fine Art

15 Cliff Street
Montpelier 05602
(802) 229-5073
www.whalenfineart.com
William Whalen Fine Art is open by appointment.

Painter Willam Whalen came to Vermont in 1971 to work with Bread and
Puppet Theater, but soon dedicated all of his time to painting and printmaking.
His landscapes and still lifes in oil, watercolor, and pastel show a devotion to
nature and a reverent contemplation of his subject.

Artisans' Hand

89 Main Street (at the corner of State Street)
Montpelier 05602
(802) 229-9492
www.artisanshand.com
The store is open daily from 10 a.m. to 5:30 p.m.; Friday until 8 p.m.; Sunday from 12 noon to 4 p.m.

This craft store in downtown Montpelier also sells prints by Mary Azarian, Sabra Field, Mary Simpson, Daryl Storrs, etchings by Kathleen Cantin, and photographs by Altoon Sultan, Tony Botelho, Richard Brown, Blake Gardner, Linda Hogan, Alistair McCallum, Peg Montgomery, and George Robinson.

Kellogg-Hubbard Library

135 Main Street (Route 12)
Montpelier 05602
(802) 223-3338
www.kellogghubbard.lib.vt.us
The Library is open Monday to Thursday from 10 a.m. to 8 p.m.; Friday, 10 a.m. to 5:30 p.m.; Saturday, 10 a.m. to 1 p.m.

The Kellogg-Hubbard Library exhibits work by students and local artists throughout the Italianate granite, Classic Revival structure.

ART AND FOOD

Capitol Grounds Café and Roastery

45 State Street (Route 2)
Montpelier 05602
(802) 223-7800
www.capitolgrounds.com
The Café is open daily.

This beanery provides gallery space for local artists. Exhibition information can be found on their website.

ART AND FOOD

La Brioche Bakery & Café

89 Main Street (at the corner of State Street)
Montpelier 05602
(802) 229-0443
www.neci.edu/restaurants.html
The Café is open daily.

On the corner of State and Main, this New England Culinary Institute-run café serves up yummy treats and a healthy dose of art.

Langdon Street Café

4 Langdon Street
Montpelier 05602
(802) 223-8667
www.langdonstreetcafe.com
The Café is open every day except Monday.

This collectively owned and operated café is home to the only completely manual espresso machine in Central Vermont and art on the walls.

Rhapsody Café

28 Main Street (Routes 2 and 12)
Montpelier 05609
(802) 229-6112

Wholesome local food and art.

ART AND HAIR

Gallery at Amaci Hair Studio

43 State Street (Route 2)
Montpelier 05602
(802) 223-2900

Exhibits work by local artists.

ART AND SHOES

The Shoe Horn at Onion River

8 Langdon Street
Montpelier 05602
(802) 223-5454
www.theshoehorn.net

This shoe store regularly announces art exhibits in *Seven Days*.

Vermont Arts Council

For most of its history, Vermont was an artistic hinterland. The state had few galleries or museums which showed contemporary art. Artists came from elsewhere, for a season or two, but ultimately went back to where they came from to sell their work and make a living. Few local artists broke out of the Green Mountains, and even fewer made their mark in the world's artistic powerhouses.

In the 1960s, as the first wave of urban refugees, libertarians, and hippies began moving into Vermont, a group of citizens came together, with the backing of the state legislature, and created the Vermont Arts Council. They set out to support artists and find ways of bolstering the role art plays in people's lives.

Anyone who appreciates the vibrancy of Vermont's art scene owes the Vermont Arts Council no small debt of gratitude. The book in your hands is a testament to their legacy. The Vermont Arts Council organizes exhibitions, provides grants to artists, maintains on online directory of artists, and provides the vital service of hosting and promoting dialogue about the economic impact and development of the arts. For artists, art venues, and art consumers alike, it is a vital community partner and catalyst.

"The Council fosters classical, traditional, and emerging forms of artistic expression. It finds enduring ways to make the arts a part of all Vermont communities, bringing inspiration to Vermont citizens and visitors in every corner of the state. It advocates for and supports the arts as a central part of education for all people."

Unlike most state arts councils, the Vermont Arts Council is unique in that it is both a grass-roots community organization and a non-profit state agency. Trustees are elected from and by its membership, not appointed by the Governor and confirmed by the legislature. This difference is fundamental. It grounds the Council in the populous of Vermont, and subject it, not to the whims of politics, but to the demands of everyday, hardworking citizens.

Art lovers are encouraged to become members of this remarkable organization. Working Vermont artists are encouraged to register with their online directory.

The Vermont Arts Council presents artwork in a number of venues, through its Art in State Buildings program and through collaborative public art projects around the state.

Vermont Arts Council Spotlight Gallery
136 State Street (Route 2)
Montpelier 05609
(802) 828-5422
www.vermontartscouncil.org

The Spotlight Gallery has rotating exhibits of artists throughout the year. Shows tend to focus on a single artist.

Governor's Office
Pavilion Building
109 State Street (Route 2)
Montpelier 05609
(802) 828-3333
www.vermont.gov/governor/

The Governor's Office exhibits work by Vermont artists.

Barre

Barre Opera House

6 North Main Street (corner of North Main & Prospect Streets)
Barre 05641
(802) 476-0292 - fax (802) 476-5648
www.barreoperahouse.org
The Opera House is open weekdays from 10 a.m. to 4 p.m. and during performances

Built in 1899 to replace the original Opera House burned the prior year, the Barre Opera House has hosted a wide array of events through the years: appearances by Helen Keller, Socialist Eugene V. Debs, and Anarchist Emma Goldman; President William Howard Taft used the outside balcony as a political soapbox in 1912; movies, variety shows, boxing and wrestling matches; and, of course, theater and opera. Angie Grace curates exhibitions of local artists in the lobby.

Aldrich Public Library

6 Washington Street (Route 302)
Barre 05641
(802) 476-7550
www.aldrich.lib.vt.us
The Library is open Monday through Wednesday from 12 noon to 8 p.m.; Thursday from 10 a.m. to 6 p.m.; Friday from 12 noon to 5 p.m.; and Saturday from 10 a.m. to 1 p.m.

The Paleteers exhibit and sell their paintings at the Aldrich Public Library. Exhibitions tend to be ad hoc and not always up, but when they are, it's worth a visit.

Studio Place Arts in Barre.

Studio Place Arts

201 North Main Street (Routes 14 and 302)
Barre 05641
(802) 479-7069
www.studioplacearts.com
Studio Place Arts is open Tuesday through Friday from 10 a.m. to 5 p.m. and
on Saturday from 12 noon to 4 p.m.

Over the past five years, Studio Place Arts (SPA) has become an important
resource for art making, learning, and exhibition. SPA reaches out to bring
all members of the community into its facility to become creators of art
through involvement in classes, workshops, lectures, and studio experiences,
and to view art that is exhibited in galleries on all three floors. SPA is widely
recognized as a friendly, accessible arts organization.

One of the great things about SPA is its willingness to conjure up a theme, see
it through, and, more often than not, pull it off so well that one has to wonder
if things weren't pre-ordained to fall into place. Their group shows are tight
and thematic and include local and national artists.

SPA is a physically accessible site with a drop-off area and public entrance
via the alley on our south side. The SPA galleries are free and open to the
public.

Surrounding Area

Blinking Light Gallery

53 Main Street (Route 2)
Plainfield 05667
(802) 454-0141
The Gallery is open Wednesday through Sunday from 10 a.m. to 6 p.m. It is always best to call ahead if you are coming from a distance or for winter hours.

Located on Main Street in Plainfield Village next to the River Run Restaurant and across from the waterfall park, the Blinking Light Gallery is the exhibition space for the Central Vermont Artists Marketing Cooperative. Member artists and supporting community members run and staff the gallery. They welcome new artist and community members. For sale at the gallery are paintings, prints, textiles to wear and for the home, photographs, pottery of all types, rustic furniture, stained glass, yarns of many types and colors, jewelry, cards, wood carvings, books, and music. Exibition of member arts are a regular feature.

Beanie Box Studio

2060 East Hill Road
Marshfield 05658
(802) 456-1978
www.beanieforpeace.com
Call for hours or to make an appointment.

David Klein's art is hysterically funny and unsentimental. It is based on Beanie the Singing Dog. Small papier maché and wood dioramas illustrate the culture of man as seen through one dog's eyes.

Events in Capital Region

JULY
Barre Homecoming Days, Barre
Downtown Barre
www.central-vt.com/web/homecoming/index.html
Held at the end of July, Barre Homecoming Days celebrates Barre City's
and Barre Town's culture and heritage. Events include art exhibits, live music
performances, stock car racing, a street dance, a very creative parade through
downtown Barre, and fireworks.

SEPTEMBER-OCTOBER
More Rock Solid, Studio Place Arts, Barre
201 North Main Street
(802) 479-7069
www.studioplacearts.org
In its fifth year in 2005, the annual Stone Show focuses on art of and about
stone reflected in the unique talents and history of regional stoneworkers.

NOVEMBER-DECEMBER
Members Show and Sale, Studio Place Arts, Barre
201 North Main Street
(802) 479-7069
www.studioplacearts.org
Studio Place Arts members present their best works for sale and holiday
gift-giving.

NORTHEAST KINGDOM

Rolling hills and charming small towns, the Northeast Kingdom is as beautiful as it is rural. Officially three Vermont counties-Orleans, Essex, and Caledonia-much of the art activity in the Kingdom runs along the Interstate 91 corridor from Derby and Newport in the north to St. Johnsbury in the south.

The region got its name in 1949 when Senator George Aiken said to a group in Lyndonville, "You know, this is such a beautiful country uphere. It ought to be called the Northeast Kingdom of Vermont."

That beauty inspires countless artists who paint and photograph the region. Life in the Kingdom is filled with church suppers, county fairs, and general store chat that translates into a community spirit that powers the art scene much more than for-profit galleries.

The efforts of Wooden Horse Arts Guild in the north, the Northeast Kingdom Arts Council in Hardwick, Catamount Arts in St. Johnsbury, and Kathy Stark and Elizabeth Nelson of Tamarack Gallery in East Craftsbury provide artists with exhibition outlets and opportunities for networking and community.

Wooden Horse Arts Guild
www.woodenhorsearts.com

"We of the Wooden Horse Arts Guild invite artists, educators, bankers, town officials, historic society members, business owners, community members, all those who truly appreciate the arts, to join us in building an arts guild to be proud of and enjoy the fruits of our artistic endeavors and the enrichment of our community."

The Wooden Horse Arts Guild supports local artists by organizing classes, ordering art supplies in bulk, creating a virtual presence online, and placing exhibits by local artists in venues in the area.

Community National Bank
4811 US Route 5
Derby 05829
(802) 334-7915
The bank is open Monday through Wednesday from 7:30 a.m. to 3 p.m.; Thursday and Friday from 7:30 a.m. to 6 p.m.; and Saturday from 8:00 a.m. to 12:30 p.m.

Dailey Memorial Library
101 Junior High Drive (off of Routes 5 and 105)
Derby 05829
(802) 766-5063
The Library is open Tuesday and Friday from 10 a.m. to 6 p.m.; Wednesday and Thursday from 10 a.m. to 5 p.m.; and Saturday from 10 a.m. to 3 p.m.

Newport Natural Foods
194 Main Street (Routes 5 and 105)
Newport 05855
(802) 334-2626
The store is open Monday through Friday from 9 a.m. to 5:30 p.m.; Saturday from 9 a.m. to 5 p.m.; and Sunday from 11 a.m. to 4 p.m.

Flying Goose Gallery

Countryside Common, 5043 US Route 5
Derby 05829
(802) 334-2685
The Gallery is open Thursday through Saturday from 10 a.m. to 4 p.m. and on
Sunday from 12 noon to 4 p.m.

Off Route 5, in between a real estate agent and a law office, this long, narrow
gallery shows over 30 northern Vermont artists. The gallery has fused glass
plates by Debra Hunt, original clay works by Goldberg, Al Diem's award
winning fish and decoy carvings, and paintings by P.J. Hammond. They also
have many other paintings and photographs by Fairbrother and Verderber, a
nationally recognized wildlife photographer.

Bread and Puppet Museum

Route 122
Glover 05830
(802) 525-3031
www.breadandpuppet.org
The Museum is open June through November, daily from 10 a.m. to 6 p.m.

"Because art is food…"

Started in the 1960's in Manhattan's Lower East Side, The Bread and
Puppet Theater made its home in Vermont a few years later. Founder Peter
Schumann's art is theater, his theater is striking visual art, anarchic, and
political. Visitors can view two floors of hundreds of puppets and masks.
Admission is free, but donations and purchases from the museum store are
welcome. Also, on Fridays and Sundays during July and August, Bread and
Puppet presents shows and pageants.

Bread and Puppet is also the fountainhead of America's Cheap Art Movement.
Launched in 1982, Cheap Art is a "direct response to the business of art and its
growing appropriation by the corporate sector." Cheap Art aspires to make art
available to everyone and to "inspire anyone to revel in an art making process
that is not subject to academic approval or curatorial acceptance."

Cheap art is art from fifty cents to fifty dollars and a lot of it is on sale at the
Bread and Puppet Museum. A catalog is available on their website.

Brown Library at Sterling College

Adjacent to the Common
Craftsbury Common 05827
(802) 648-3591
www.sterlingcollege.edu
The Library is open to the public during office hours.

Originally founded as an alternative boys' prep school in the 1950's, Sterling College went through a number of changes before receiving full accreditation as place of higher education. The college offers experiential education and teaching facilities include "a managed woodlot, a climbing wall, an organic garden, a moveable hoop-house, a glass greenhouse, and a working livestock farm with two barns." Brown Library is open 24 hours a day to students and staff and operates on the honor system. Library walls feature rotating exhibitions by Vermont artists. Exhibitions change every six weeks; shows begin on Sunday afternoons with an artist reception.

Jerry Ralya Figure Studies

7909 Vermont Route 14
Craftsbury Common 05827
(802) 586-2556
The Studio is open by appointment.

Two miles south of Albany village, just after the town line you'll see a red house on the right that is the home and studio of Jerry Ralya. A rare figurative artist, Jerry creates remarkable monochromatic pastels of nudes and other themes. His work can also be seen at The Art Gallery in Stowe.

Tamarack Gallery

East Craftsbury Road
East Craftsbury 05826
(802) 525-3041 or (802) 586-8078
www.tamarackvermont.com
The Gallery is only open the months of July and August on Saturday and Sunday from 11 a.m. to 5 p.m.

Housed in a big, barely-adapted yellow barn, the Tamarack has rough, wood floors, two pianos, lots of comfy chairs and space to hang out in. Open only two months out of the year, the rest of the time, the building is used as a rehearsal space for the Craftsbury Players. Sixty artists from around the country are on display. Park in front of the gallery, not in the driveway. The gallery is across from East Craftsbury Road and Cate Hill Road intersection. Look for the sign.

Greensboro Free Library

53 Wilson Street
Greensboro 05841
(802) 533-2531
The Library is open Monday, Thursday, and Friday 10 a.m. to 5 p.m; Tuesday from 10 a.m. to 7 p.m.; Saturday from 10:30 a.m. to 12:30 a.m.; and Sunday 11:30 a.m. to 12:30 p.m. In Summer, Monday through Friday hours are 10 a.m. to 4 p.m.

Greensboro's public library also serves as an exhibit space for local artists.

The Miller's Thumb

4 Main Street
Greensboro 05841
(802) 533-2960
The Miller's Thumb is open seven days a week from 10:30 a.m. to 5:30 p.m.

The Miller's Thumb sells a wide assortment of fun, fine goods (Italian pottery, specialty food, clothing, furniture, etc) in an old mill located across from the general store in Greensboro. In the center of the store, one can still look down the shaft and see the river underneath. On the walls (both downstairs and up) is work by local artists.

Marie LaPré Grabon Fine Art

1873 Bunker Hill Road
Hardwick 05843
(802) 472-6908
www.polydolls.com
The Studio is open by appointment.

Marie LaPré Grabon creates mixed media drawings, and mixed media art dolls. The dolls include polymer clay, fabric, beads, wire and papier maché. They have been described as colorful and whimsical, and expressive in form and intention. Vine charcoal, colored pencils, and New Pastels are the media she uses to make her expressive figurative drawings.

Grassroots Art & Community Effort (GRACE)

13 Mill Street (Route 15)
Hardwick 05843
(802) 472-6857
www.graceart.org
Open Tuesday, Wednesday, and Thursday from 10 a.m. to 4 p.m. or by appointment.

In 2000, Grassroots Arts and Community Effort, or GRACE as most people know it, took over the old firehouse in downtown Hardwick and turned it into an art center. The historic firehouse was built in 1885 and is located in the heart of Hardwick's commercial district. GRACE always seems to be at the heart of it all. It began in 1975 at the St. Johnsbury Convalescent Center. Their mission is to "discover, develop, and promote visual art produced primarily, but not exclusively, by elderly self taught artists in rural Vermont." Originally conceived as a program for instruction, founder Don Sunseri quickly realized was that participants had a remarkable talent for creating narrative, sometimes autobiographical, imagery.

Considered folk or outsider art, the work of GRACE participants have been recognized with numerous exhibitions in Vermont and New York City and work has found its way to a number of private and public collections. Gayleen Aiken, a GRACE artist, was the subject of a film by Jay Craven and in 1997, *The Enchanted Word of Gayleen Aiken* was published by Harry Abrams, Inc. Artwork is for sale at GRACE in Hardwick and online at the organization's website.

Great and Small Creations

1618 Bunker Hill Road
Hardwick 05843
(802) 472-5471
www.vtbronzeart.com
By Appointment

In a bright yellow house with an orange roof and green trim, Nancy Schade creates sculpture and paintings. The gallery exhibits bronze sculptures made using a lost wax process. Her paintings reflect her life in Vermont and Mallorca, Spain.

GRACE in Hardwick.

Hardwick Town House

Home of Northeast Kingdom Arts Council
127 Church Street
Hardwick 05843
(802) 472-8800
www.nekarts.org
Open during events and performances, on Sundays 11 a.m. to 3 p.m. and by appointment.

The Northeast Kingdom Arts Council is a non-profit organization based in the historic Hardwick Town House. They provide both educational and entertaining programming to the residents of the Northeast Kingdom and surrounding areas while preserving and maintaining the Hardwick Town House which has a gallery that shows the work of local artists. In front of Town House are two metal and oak sculptures by James Teuscher titled *Cross* and *Double Cross*.

J. Hallowell Art Metal

836 Morrill Road
North Danville 05828
(802) 748-1035
www.vtartmetal.com
The studio and gallery are open by appointment or by chance.

From Danville, take Hill Street which becomes the Bruce Badger Memorial Highway, then left on dirt Morrill Road until, on the right, you see a yellow sign: Hallowell Art Metal.

"I call it my idea space," says metal artist Joe Hallowell. The driveway overlooks a mowed field full of huge outdoor sculptures: ten foot tall red forks with black crows perched atop, large, fifteen foot tall blue herons, roosters, giraffe, sunflowers and more. Some work is abstract. A small gallery space is on hand that shows some of Joe's architectural and furniture work. Be sure to sit in the spider chair.

Parker House Gallery

511 Bayley Hazen Road
Peacham 05862
(802) 592-3161
www.parkerhousegallery.com
The Gallery is open Tuesday through Sunday from 10 a.m. to 5 p.m.

The Parker House Gallery features work by professional artists, many of who were trained at the Art Students League of New York City. Examples include Sara Simboli's still-lifes, Tim Brewer's classic paintings, fine prints by R. W. Darling, and Kim Darling's expressive oils. Work is featured in a lovely 1830 Greek revival named after Peacham's mid-1800s physician Dr. Luther Fletcher Parker, a former resident of the house.

Marjorie Kramer

1893 Valley Road
Lowell 05847
(802) 744-6859
Ms. Kramer's studio is open on Saturday by appointment.

Kramer is a painter with roots in Vermont and New York City. Most of her work consists mostly of two sorts of paintings, one: self portraits done over the past 35 years of stages in her life such as, discovering the feminists, moving to the country, breastfeeding her daughter, becoming ill with cancer and recovering, in work clothes. Two: large landscapes often done in the woods. She also loves to paint images of general store/gas stations by the side of the road. She also has prints and figure drawings, in a figurative, modernist or post-modernist style with a healthy love of Chinese, French and Italian paintings of the past.

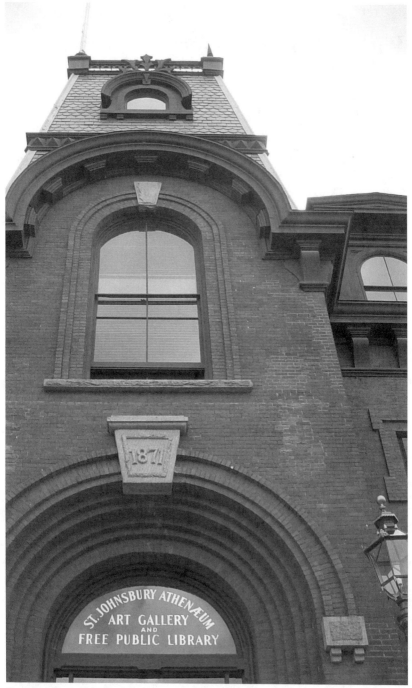

St. Johnsbury Athanaeum and Art Gallery .

Catamount Arts

139 Eastern Avenue (Route 2)
St. Johnsbury 05819
(802) 748-2600 or (888) 757-5559
www.catamountarts.com
Open Monday through Friday from 1 p.m. to 6 p.m. In addition, the galleries
are available to visitors before and after the nightly film screenings.

Founded in 1975, Catamount Arts works to enhance the cultural climate
of northern Vermont and New Hampshire. The Center on Eastern Avenue
opened in 1985 and includes a 100-seat theater, classrooms, offices, and
art galleries that support local artists. Exhibitions rotate monthly. Catamount
Arts also offers classes, museum bus trips, and an extensive list of film and
performances throughout the year.

St. Johnsbury Athenaeum Art Gallery

1171 Main Street (Route 2)
St. Johnsbury 05819
(802) 748-8291
www.stjathenaeum.org/artgall.htm
The Athenaeum is open Monday and Wednesday 10 a.m. to 8 p.m., Tuesday,
Thursday and Friday from 10 a.m. to 5:30 p.m.; and Saturday from 9:30 a.m.
to 4 p.m.

Often referred to as the "oldest public art gallery in the United States," the St.
Johnsbury Athenaeum is a trip into a 19th century world of art and learning.
The elegant 1887 French Second Empire-style building houses a public library
and art gallery. Marble statues perch atop pedestals. Paintings hang in gilded
frames in salon style. The children's room has murals painted in 1934 by
Marjorie Lang. While there is no contemporary art, the Athenaeum's extensive
collection of European and early American art that no doubt inspired resident
and visiting artists in the Northeast Kingdom throughout the twentieth century.

Stephen Huneck Gallery & Dog Chapel

143 Parks Road
St. Johnsbury 05819
(802) 748-2700
www.huneck.com
The Gallery is open Monday through Saturday from 10 a.m. to 5 p.m. and
Sunday from 11 a.m. to 4 p.m.

"Do what makes you happy. I love my dogs so I portray them in my art,"
is how Stephen Huneck, one of Vermont's most commercially successful
artists, sums up his philosophy. His studio and gallery is a special place in
St. Johnsbury.

Located on the top of a hill, the gallery shows original artwork, prints, books,
and other goods in Huneck's trademark style. A self-taught artist, Huneck
started out as a carver and furniture maker. His prints are woodcuts and
demonstrative of his eye for good design, fantastic sense of humor, and deep
love of dogs.

In 1994, Stephen had a near death experience that left him in a coma for two
months after which he had a vision of building "a place where people can
go to celebrate the spiritual bond they have with their dogs." That vision was
realized with Dog Chapel

Quite a few artists have created spiritual buildings as a vehicle for their work,
but none have dedicated them to man's four-legged companions. The lobby
of the chapel is a remembrance wall with pictures and notes about pets that
have passed. The main rooms have a few pews, stained glass windows, and
Huneck's sculptures.

Dog Mountain is a peaceful place. Across from the gallery is a pond and
pleasant views. Trails run through the surrounding woods.

See also, Stephen Huneck's Gallery in Woodstock on page 164.

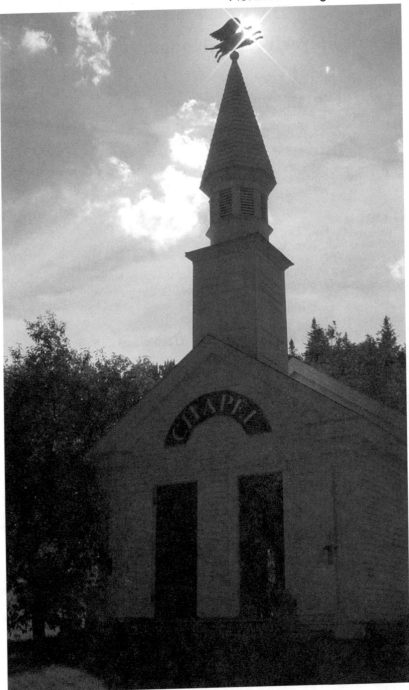

Dog Chapel at Stephen Huneck Gallery in St. Johnsbury.

Events in Northeast Kingdom

JUNE-AUGUST
Gateway Concert and Arts Series, Newport
Gateway Center, behind City Hall
Vermont Mountain Arts displays and sells art before and after concerts. The concerts are on Lake Memphremagog and the art is inside the Gateway Center. Concerts are held throughout June, July and August. Look for schedules posted around town or check the North Country Chamber of Commerce website (www.vtnorthcountry.org).

JULY
Burklyn Arts Fair, Lyndonville
Bandstand Park, Town Green, Route 5
(802) 626-6210 or (802) 748-7895
The Burklyn Arts Fair has been held for over 35 years on a Saturday in July. The fair includes 60 juried Vermont artists, live Irish music, and food.

AUGUST
Derby Line Community Day and Town Wide Yardsale, Derby Line
Baxter Park and throughout the Village
(802) 873-3420 or (802) 873-3454
Derby Line abuts the Quebec border. In fact, the Haskell Opera House and Library straddles the border. The Yard Sale is in the morning and there are fireworks at dusk. Throughout the day, until about 5 p.m., there are all kinds of activities in Baxter Park, including art exhibits.

OCTOBER
North Troy Village Arts Show, North Troy
Congregational Church
(802) 988-2259
www.woodenhorsearts.com
Held over Columbus Day/Canadian Thanksgiving Weekend, this is a fine art and crafts show featuring international artists. Sponsored by the Wooden Horse Arts Guild.

UPPER VALLEY

White River Junction ♦ Randolph ♦ Bridgewater
Woodstock & Quechee ♦ East Thetford ♦ Windsor

The Upper Valley is Vermont's Eastern Gateway, where Interstate 91 and US Route 5 meet Interstate 89 and US Route 4 as they cross from New Hampshire. Close to Dartmouth College, many Upper Valley residents live in Vermont, but work in New Hampshire.

White River Junction, a former mill town, is experiencing an artistic resurgence with the creation of the collaborative art and commerce space, The Tip Top Media and Arts Building. Driving west from White River Junction along Route 4, you pass through Quechee, with its gorges and covered bridge, to Woodstock. Woodstock is a perennial favorite destination of tourists and Vermonters alike and boasts a large number of fine art venues. Further west along Route 4, toward Killington, is the town of Bridgewater and its historic mill, which was seriously damaged in a flood and now serves as a shopping and art hub.

Traveling north and west out of White River Junction, along Interstate 89 towards Barre and Montpelier, you come to the town of Randolph. Main Street in Randolph is part of the National Main Street Program and the village of Randolph is a National Historic District. The Chandler Center for the Arts features a wide variety of visual and performing arts throughout the year.

A trip north along Route 5 and the Connecticut River toward East Thetford and the Northeast Kingdom is always beautiful no matter what the season.

In 1777, Windsor became the birthplace of the Republic of Vermont when it was the site of the writing of the republic's constitution. Now a town of 3,800 about 12 miles south of White River Junction, it is filled with historic buildings and homes. Its recently renovated Firehouse has become the home of the Cornish Colony Museum.

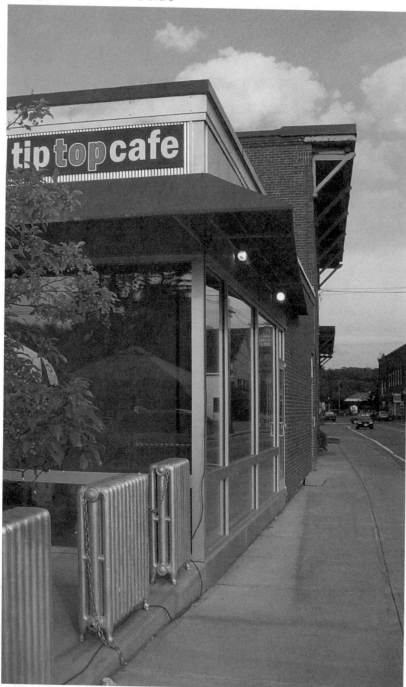

Tip Top Media and Arts Building in White River Junction.

White River Junction

Tip Top Media and Arts Building

85 North Main Street
White River Junction 05001
(802) 356-1933
www.tiptopmedia.com
The Building is open to the public Monday through Saturday.

Once a thriving bakery along the banks of the White River, Tip Top Building now houses 40 artists and businesses in a creative-collaborative environment. A project of Matt Bucy, he acquired the building in 2000 and has been renovating, repairing, and restoring it every since. With over 1,000 feet of wall space (and a few dozen artists), the inside of building is covered with art. Artists hang work at their discretion. Frequent open houses and other events make Tip Top a hub of creative activity.

Among the artists studios housed in the building is filmmaker, painter and Tip Top founder Matt Bucy, photographer Sally Carpenter, painter Georgina Forbes, sculptor Sande (Duckworth) French-Stockwell, painter Rebecca Gottesman, painter Ann Holloway, painter Ann Johnston, painter Mark Merrill, sculptor Bill Nutt, painter Virginia Webb, painter Coralea Wennberg, and painter Tina White. Tip Top is also home to a classy café, a paint your own pottery studio, and Chelsea Green Publishers.

Cooler Gallery

Tip Top Media and Arts Building
85 North Main Street, Suite 250
White River Junction 05001
(802) 280-1864
www.coolergallery.com
The Gallery is open Tuesday to Saturday, 11 a.m. to 4 p.m. or by appointment

In what once served as the cold storage room of the Tip Top Bakery, the Cooler Gallery focuses on rotating exhibitions of regional contemporary artists. A good floor plan and nice lighting, not to mention consistently good choices of art, make this a great venue to visit.

Northlight Digital Gallery

Tip Top Media and Arts Building
85 North Main Street, Suite 146
White River Junction 05001
(802) 280-1888
www.northlightdigital.com
The Gallery is open to the public at all times when the Tip Top Media Arts building is open, daily from 8 a.m. to 9 p.m.

Northlight Digital is a digital imaging, photography and printing business that includes a photo gallery space. They exclusively scan and print the Collamer Abbott Collection: a large collection of black and white historical and documentary photos of the Upper Valley area from the 1950s by local photojournalist Collamer Abbott. Photos from the collection on their website which also has up-to-date information about exhibitions.

Two Rivers Printmaking Studio

Tip Top Media and Arts Building
85 North Main Street, Suite 160
White River Junction 05001
(802) 295-5901
www.tworiversprintmaking.com
The Studio welcomes visitors, but please call ahead.

Two Rivers Printmaking Studio supports working artists' exploration of print-making media, and builds interest in the art and history of the print through workshops, seminars, lectures, and exhibitions.

On the walls of the print studio in the Tip Top Building, Two Rivers exhibits and sells work by members. Artists represent a diverse selection of printmaking media including relief, intaglio, stone and plate lithography; monotype; and serigraphy printmaking as well as their photographic adjuncts. Their website has an online gallery of various members' work.

Randolph

Chandler Gallery
Chandler Center for the Arts
73 Main Street
Randolph 05060
(802) 728-9878 - fax (802) 728-9878
www.chandlermusichall.org/gallery.cfm
The Gallery is open Saturday and Sunday from 10 a.m. to 12 noon; Thursday
from 4 to 6 p.m.; and by appointment.

Chandler Gallery is a year-round, non-profit art gallery housed in the same
building as the historic Chandler Music Hall in Randolph. Predominantly run
by volunteers, the gallery holds 8-10 shows a year, covering a wide range
of artists, artisans and crafters in a variety of mediums. The annual "Local
Artist Show" is held in April, coinciding with the popular "Mud Season Talent
Show" presented in the Music Hall next door. From a single renowned artist to
acclaimed traveling shows, Chandler Gallery's varied shows are influenced by
the enthusiasm, style and innovation of the creators while complementing the
performances at the Music Hall.

Bridgewater

Bridgewater Mill
US Route 4 on the Bridgewater-Woodstock Town Line
Bridgewater 05034
(802) 672-3332
www.thebridgewatermill.com

The Bridgewater Mill is a sprawling yellow complex on Route 4 along the
banks of the Outtauquechee River. The original Bridgewater Woolen Mill
was built in 1825 with additions added in 1872. A devastating flood in 1973
destroyed the dye room. The Bridgewater Mill Mall was created in 1978. The
mill is now home to 20 shops, artist studios, service providers and workshops,
as well as Bridgewater's post office. The building is hard to miss, but the
entrance might be. Look for the large green sign just past the mill (if coming
from the west) or just before it (if coming from the east).

ART AND FOOD

Tip Top Café

85 North Main Street
White River Junction 05001
(802) 295-3312
The Café serves lunch between 11:30 a.m. and 2 p.m. and dinner between 5 p.m. and 9 p.m. Tuesday through Saturday.

The Tip Top Café serves nouvelle cuisine in a casual, modern environment. There is an outdoor terrace. Art by local artists hangs thoughout.

Main Street Museum

58 Bridge Street
White River Junction 05001
(802) 356-2776
www.mainstreetmuseum.org
The Museum is open Thursday through Saturday from 1 to 6 p.m.

Now relocated to the old Fire Station on Bridge Street, the Main Street Museum is both a fine art venue and museum of oddities. The fine art is shown in the front of the museum and is work by artists who "need shows". The work is for sale and the museum takes no commission. There are three shows a year. The museum's oddities include stuffed animals, portraits of dogs, and found objects. The museum also curates the Museum of Industrial Antiquities on the ground floor of the Tip Top Media and Arts Building at 85 North Main Street.

Woodstock & Quechee

Polonaise Art Gallery

15 Central Street (Routes 4 and 12)
Woodstock 05091
(802) 457-5180
www.artpolonaise.com
The Gallery is open Sunday, Monday, and Friday from 11 a.m. to 5 p.m.;
Tuesday through Thursday from 11 a.m. to 2:45 p.m.; and Saturday from 10
a.m. to 5 p.m.

Gallerist Wojtek Pilczynski is passionate about this two-story gallery located
in the heart of Woodstock. Polonaise shows high quality fine art from interna-
tional artists. On view is work by artists from Germany, Brazil, Japan, Italy,
and Grenada, to name a few. The art is diverse, combining contemporary and
traditional styles; abstracts and nudes and landscapes.

Work includes Ken Davis's large paintings of trains, shop windows, and water
towers on antique barn doors; Michael Palmer's large acrylic landscapes; and
Barbara Wagner's abstract oils on linen. The gallery itself is comfortable and
friendly. Wojtek is often on hand to answer questions or talk about the artwork.

Caulfield Art Gallery

11 The Green (Route 4)
Woodstock 05091
(802) 457-1472
www.caulfieldartgallery.com
The Gallery is open daily from 10 a.m. to 5 p.m.

The Caulfield Art Gallery is the showplace for the work of Robert O. Caul-
field. He was named by *Art Trends* as both one of "the leading street painters
in the nation" and one of "the leading Impressionists in the nation." The
gallery is housed in a large, brick home built in 1827 that faces both the Green
and the Outauquechee River. Caulfield's career as an artist spans 50 years. The
art on display is both in oil and watercolor and includes cityscapes of New
York, Paris, Boston, and Venice, as well as landscapes of Vermont and beach
and flower scenes.

Woodstock Folk Art Prints & Antiquities
6 Elm Street (Route 12)
Woodstock 05091
(802) 457-2012
www.woodstockfolkart.com
The gallery is open Monday through Saturday from 10 a.m. to 5 p.m. and
Sunday from 10 a.m. to 4 p.m.

Woodstock Folk Art was born in 1995 from the print and folk art portion
of Woodstock's venerable Gallery 2, founded in 1956 by Ellison Lieberman.
The majority of the artists represented are Vermonters, including some previ-
ously represented by Gallery 2, such as printmaker Sabra Field. The list also
includes Victoria Blewer, Woody Jackson, Margaret Lampe Kannenstine, and
Mary Welsh.

Fox Gallery Fine Arts
5 The Green (Route 4)
Woodstock 05091
(802) 457-3944
Call the Gallery for hours.

This gallery, housed in a large, brick colonial home facing the green, presents
the work of painter Neil Drevitson, who creates impressionistic landscapes. He
works mainly in pastel, but also does watercolor or oil paintings.

Stephen Huneck Gallery
49 Central Street (Routes 4 and 12)
Woodstock 05091
(802) 449-2580
www.huneck.com
The Gallery is open Monday through Saturday from 10 a.m. to 5 p.m. and
Sunday from 11 a.m. to 4 p.m.

Dogs are welcome at this whimsical gallery in downtown Woodstock.
Huneck's woodcuts, sculpture, furniture, and books are on display. See page
154 for more information about Stephen Huneck.

Gallery on the Green

1 The Green (at the corner of Elm Street, Routes 4 and 12)
Woodstock 05091
(802) 457-4956
www.galleryonthegreen.com
The Gallery is open Monday through Saturday from 9:30 a.m. to 5 p.m. and on Sunday from 10 a.m. to 4 p.m.

"An art gallery should be a source of entertainment. It should be a place to enjoy. It should be a place to come back to time and time again."

Located in the heart of Woodstock, Gallery on the Green sells fine art painting, prints and sculpture from around New England. In seven rooms, Jan and Jim Allmon exhibit work by established, recognized artists. Almost all of the work is representational. Gallery on the Green is one of the few galleries in Vermont with an active Secondary market. On view is work by deceased artists and paintings being resold.

A note about the building: Gallery on the Green is housed in the historic Titus Hutchinson House, which operated as the White Cupboard Inn from 1925 to 1960. The ski tow was invented there as a way to help middle-aged skiers to the top of the local ski hill.

Pegasus Gallery

3479 Woodstock Road (Route 4 next to the Quechee Mobil)
Quechee 05059
(802) 296-7693
www.pegasusgalleryvt.com
The Gallery is open May through October, Wednesday through Friday from 10 a.m. to 5 p.m. Other times of the year, the Gallery is open Friday through Sunday from 10 a.m. to 5 p.m. and by chance or appointment.

The Pegasus Gallery is in an unlikely location-next to the Quechee Mobil, but this fits the gallery's mission. "Every life should include a healthy dose of art to maintain one's aesthetic health." Pegasus features fine art and crafts from around the region, including painting and sculpture, glass and wood, jewelry, and pottery.

V Gallery

1211 Vermont Route 12
Woodstock 05091
(802) 457-9294
www.vgalleryarts.com
The Gallery is open daily, except Tuesday, from 11 a.m. to 5 p.m.

V Gallery Central

6 Central Street (Routes 4 and 12)
Woodstock 05091
(802) 457-2200
www.vgalleryarts.com
The Gallery is open Monday through Saturday from 10 a.m. to 5 p.m. and
Sunday from 11 a.m. to 4 p.m.

Two locations, one name: V Gallery promotes Vermont arts and lifestyles.
"Producing, providing and promoting nature's artistic expression with the
inspirational help of exceptionally talented local and regional artists."

Art and furniture are presented together in the gallery. On hand is work by
twenty-two painters, nine sculptors/wood turners and three photographers. The
gallery also serves as a guild for thirteen furniture makers.

Rotating exhibits are updated monthly. Some featured artists have included
abstract painter Jim Grabowski, wood turner Dustin Coates and sculptor
Hector Santos.

Todd Reuben Stainless Steel Sculpture

100 Brown Road
Woodstock 05091
(802) 457-4172
The Studio is open daily from 10 a.m. to 6 p.m.

Todd Reuben chooses stainless steel as his medium. He says, "like gold,
stainless steel is immutable; it does not tarnish or rust, retaining its quality
forever. When refined and then polished to a high luster, the reflective quality
of its surfaces endows the sculpture with a fluidity and liveliness, thereby
enhancing and accentuating the flow of the piece."

ART AND FOOD

Prince & The Pauper Restaurant

24 Elm Street (Route 12)
Woodstock 05091
(802) 457-3313
www.princeandpauper.com
The Restaurant serves dinner nightly beginning at 6.

Tucked away off of Elm Street, The Prince and The Pauper provides fine dining in a casually elegant setting. While dining, enjoy the art from around the region. The artist Margaret Lampe Kannenstine regularly shows her work at the restaurant.

East Thetford

ART AND FOOD

Isabell's Café

3052 Route 5
East Thetford 05043
(802) 785-4300
The Café is open Monday through Saturday from 7 a.m. to 2 p.m.

Isabell's offers occasional shows of work by Upper Valley artists while serving local produce, syrup and honey. The menu includes fresh baked goods, soups and made-to-order sandwiches.

Windsor

Lawrence J. Nowlan Sculpture

53 Main Street (Route 5)
Windsor 05089
(802) 674-2222
www.ljnsculpture.com
By Appointment.

Did you ever wonder where oversized statues of Heisman Trophy winners came from? Lawrence Nowlan makes large figurative clay and bronze sculpture, busts, and bas relief. Located in an old Unitarian church in downtown Windsor, Nowlan's studio is a fascinating place to visit.

Cornish Colony Museum

Old Firehouse Building, 147 Main Street (Route 5)
Windsor 05089
(802) 674-6008
www.cornishmuseum.com
The Museum is open from Memorial Day weekend to the end of October, Tuesday through Saturday from 10 a.m. to 5 p.m. and on Sunday from 12 noon to 5 p.m. Closed on Monday, except Memorial Day. An admission fee is charged.

The Cornish Colony was created by a group of established painters, sculptors, writers and politicians that lived in Plainfield and Cornish, New Hampshire and Windsor, Vermont during the late 19th and early 20th centuries. The museum, moved to Windsor from Cornish, New Hampshire in 2005, now houses a collection of works by many colony members, with a focus on Maxfield Parrish and Augustus Saint-Gaudens. Saint-Gaudens' home, Aspet, across the river in Cornish is now a National Historic Site. Paintings and sculpture by Paul Manship, Frederick Remington, George de Forest Brush, Frances Grimes, Everett Shinn and Thomas and Maria Dewing are also on display.

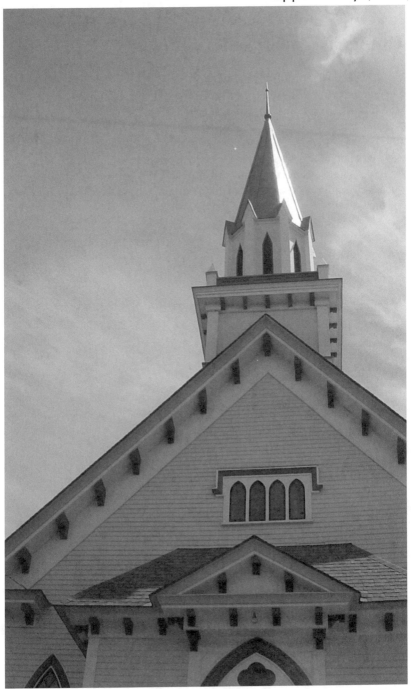

Lawrence Nowlan's Sculpture Studio in Windsor.

Events in Upper Valley

OCTOBER
Vermont North by Hand Open Studio Tour, Orange County
Bradford, Corinth, Topsham, and Groton
Area bounded by Routes 5, 25, and 302
(802) 439-6921
Always held the first weekend in October, Vermont North by Hand Open Studio is a time when artists and craftspeople in this corner of Orange County open their studios to visitors. Look for maps and schedules in the towns on the tour.

CONNECTICUT RIVER

Springfield ◆ Chester ◆ Grafton ◆ Townshend
Bellows Falls ◆ Putney ◆ Brattleboro ◆ Marlboro

The Connecticut River Valley is full of history and art venues. Hugging the riverbank with forays short distances inland, the Connecticut River Valley has been an inspiration to artists for generations.

Springfield, at the junction of Routes 11 and 106, was once a thriving manufacturing town and the heart of "Precision Valley". It is now celebrating and rediscovering its past, encouraging historical investigation and artistic creativity.

Traveling south from Springfield along Route 11, the typically quaint town green of Chester appears. Traveling further south along Route 35, the villages of Grafton and Townshend beckon. These small towns attract hundreds of tourists each year, as well as professional and amateur artists alike.

Bellows Falls, accessible from Interstate 91 and Route 5 from the north and south and Route 121 from Grafton, is, like Springfield, experiencing a renaissance as it redefines itself from mill town to 21st century cultural center. Bellows Falls hosts a large number of art venues and two arts organizations, the Rockingham Art and Music Project and the Great River Arts Institute. Every third Friday evening, the Art Walk showcases what is current in the local art scene.

At the Great River Art Institute, one can take classes by some of the region's most well-known and talented artists. These include landscape painter Eric Aho, Doug Trump, master printer Sarah Amos, Catherine Farish, and many others. Great River Arts can be found online at www.greatriverarts.org.

Moving south along the river, Putney is home to the world-famous Putney School and the Putney Craft Tour. The tour, held the weekend after Thanksgiving, is the longest-running open studio tour in the United States.

Brattleboro, in Vermont's southeastern corner, is a hotbed of artistic

activity. One can see art up and down Main Street and not just during the First Friday Gallery Walk, which is known throughout the state. Along with a large number of galleries and retail and dining establishments that show art, Brattleboro is also home to the Brattleboro Museum and Art Center and the Vermont Center for Photography. Just to the west of Brattleboro along Route 9, the town of Marlboro is the home of Marlboro College and its Drury Art Gallery

Springfield

Gallery at the VAULT

68 Main Street (next to the Morning Star Café, Route 11)
Springfield 05156
(802) 885-7111
www.galleryatthevault.com
The Gallery is open Tuesday, Wednesday and Thursday from 11 a.m. to 3 p.m.
and Friday and Saturday from 11 a.m. to 7 p.m.

The non-profit Gallery at the VAULT's name has a dual meaning. There is an
actual vault in the gallery, which is housed in the restored 1908 Bank Block
Building. VAULT also stands for Visual Art Using Local Talent. The gallery
showcases over 80 mixed-media, juried local and regional artists. Part of the
gallery houses the Open Wall, which is a continuous, non-juried art show open
to artists living within 30 miles of Springfield. Three shows are presented
annually for three months at a time between February and October.

Miller Art Center

9 Elm Street
Springfield 05156
(802) 885-2415
www.millerartcenter.org
The Center is open mid-April to November 1st, Tuesday through Friday from
10 a.m. to 4 p.m. and Saturday from 2 to 5 p.m.

Located in a Civil War-era mansion overlooking Springfield, the Springfield
Art & Historic Center and Miller Art Center houses a museum and gallery. The
Edward Miller family donated the mansion to the Springfield Art and Histori-
cal Society in 1956. The gallery features rotating and permanent exhibits
(primitive portraits, pewter, Bennington pottery, Joel Ellis dolls, and locally
made toys), work by local artists, educational programs and more. The Cen-
ter's primitive portrait collection from the 19th century has work by Horace
Bundy, Asahel Powers, and Aaron Dean Fletcher. Contemporary local artists in
the collection include Stuart Eldredge, Joe Henry, Horace Brown, and Hazel
Kitts Wires. The Center also showcases Springfield's role as Precision Valley,
home of former major machine tool manufacturers, and as a center for toy
making in the early 19th century. The grounds are open and provide views
of downtown Springfield. The Black River's Comtu Falls can be heard from
the grounds.

Chester

Chester Art Guild

Old Academy Building, Village Green, Route 11
Chester 05143
(802) 875-3767
The Guild's gallery is open late May through mid-October, Friday through Sunday from 11 a.m. to 4 p.m.

The Chester Art Guild shares its space with a historical society in the former Chester Academy building on Route 11. This multimedia art gallery is most noted for its occasional lawn sales, where visitors can meet with artists and purchase their works (all proceeds go towards artistic scholarships and furthering arts in the region).

Ten Chester artists founded the Guild in 1959 as a way to encourage interest in cultural activities. Today the Guild has a gallery, open studios, and an academy for adults and children. Come by Tuesdays and Saturdays from 9 a.m. to 12 noon and join the Studio Group, an informal gathering of artists. There is no formal instruction, but "helpful advice is always available." Bring your art and a bag lunch!

Crow Hill Gallery

729 Flamstead Road
Chester 05143
(802) 875-3763
www.crowhillgallery.com
The Gallery is open Wednesday through Sunday from 10 a.m. to 5 p.m.

Crow Hill Gallery is located on the side of Crow Hill, in a wooded, yet airy setting. The artist Jeanne Carbonetti and her husband, Larry, designed and built the fine art gallery, as well as the Colonial Williamsburg-inspired winter studio, and the trails on the property that provide opportunities for quiet reflection and viewing outdoor sculptures. Jeanne's primary medium is watercolor with an emphasis on the "fluidity of color." Her work is displayed in a home-like setting on paneled walls with bookcases and comfortable furniture. "Art is not a luxury, it is a necessity, not just for society, but for every individual as well."

Reed Gallery

The Green (entrance behind Raspberries & Tyme)
Chester 05143
(802) 875-6225
The Gallery is open Thursday through Monday from 10 a.m. to 5 p.m. or
by appointment.

Ask art lovers in Chester where to see art and everyone will mention the
Chester Art Guild and the Reed Gallery. In a converted early 20th century
car garage, the Reed Gallery is an evolving co-operative space showing the
Maine Coast landscapes of Elaine Reed, paintings and sculpture by local
artists, handmade baskets and jewelry. Recent shows have included paintings
by Jessica DiClerico and sculptures by Oliver B. Schemm.

ART AND FOOD

Baba à Louis Bakery

Route 11 West
Chester 05143
(802) 875-4666
www.lcturbonet.com/~lmeyers/bakery/
Baba à Louis Bakery is open Tuesday through Saturday from 7 a.m. to 6 p.m.
Closed April and November. Open for Thanksgiving.

Off Route 11 a little, in a specially-designed building next to an old bar, Baba
à Louis Bakery offers high quality breads, baked goods, and lunch. Art from
the area graces the walls.

Grafton

Gallery North Star
151 Townshend Road (Route 35)
Grafton 05146
(802) 843-2465
www.gnsgrafton.com
The Gallery is open daily from 10 a.m. to 5 p.m. (Tuesday by chance) and
by appointment.

Gallery North Star, opened in 1975, has over 2,200 square feet of exhibit
space in its restored 1877 village house in historic Grafton village. Focusing
on the work of over 25 Vermont and New England artists, the Gallery shows
work in oil, watercolor, and sculpture in a diverse selection of artistic styles.
Original artwork is the focus of the offerings since the gallery was purchased
by Edward and Kim Bank in 2004. Represented artists include Henry Isaacs,
Robert Huntoon, Robert Carsten, Phyllis Chase, and Mel Hunter.

Jud Hartmann Gallery
6 Main Street
Grafton 05146
(802) 843-2018
www.judhartmanngalley.com
The Gallery is open daily from mid-September through New Year's only.

The Gallery specializes in bronze sculptures, Native American art, historical
art, and fine art. Along with paintings by William Bracken and Jerry Rose,
the gallery features a unique series of limited edition bronze sculptures: *The
Woodland Tribes of the Northeast*, which has been Hartmann's primary artistic
focus since 1983.

Townshend

Taft Hill Collection and Art Gallery

1096 Vermont Route 30
Townshend 05353
(802) 365-4200 - fax (802) 365-4420
www.tafthill.com
Taft Hill is open Tuesday through Sunday from 10 a.m. to 5 p.m.

The Taft Hill Art Gallery opened July 2005 inside the Taft Hill Collection, which sells fine gifts, antiques and accessories. Taft Hill is housed in the Wheelock House, a Georgian mansion built circa 1858 and is on the National Register of Historic Places. Old maples line the driveway as you approach. There are four main rooms, with one designated as a gallery space. The art on display is by regional artists in a variety of media: wood cut, photography, pencil drawings, mixed-media, watercolor, oil, magic marker, sculpture, glass, and prints. The remaining rooms of the ground floor are retail space for the Taft Hill Collection and Crest Studios, which has live demonstrations of hand-painting glass and china.

Kim Eng Yeo Studio

628 Peaked Mountain Road
Townshend 05353
(802) 365-4521 or (718) 591-5639
www.kimengyeo.com
Ms. Yeo's studio is open by appointment only.

Originally from Singapore, Kim Eng Yeo is an artist who divides her time between Vermont and New York. She is a realist painter who uses transparent watercolors as her primary medium for her floral, still life and landscape subjects.

Spheris Gallery in Bellows Falls.

Bellows Falls

Spheris Gallery

59 The Square
Bellows Falls 05101
(802) 463-2220
www.spherisgallery.com
The Gallery is open Tuesday through Friday from 10 a.m. to 5:30 p.m. and on
Saturday from 12 noon to 5:30 p.m.

The Spheris Gallery, the partner gallery to Reeves Contemporary in New York
City, is located on The Square, in the center of town. Monthly shows are
focused on the work of contemporary artists, many from the Connecticut River
Valley. Among the artists represented by Spheris are: Eric Aho, Doug Trump,
Jim Florschutz, Craig Stockwell, and Peter Brooke. Donald Saaf and Julia
Zanes of Saxtons River have also been featured artists.

Richter Gallery

3 Westminster Street
Bellows Falls 05101
(802) 463-2049
The Gallery is Tuesday to Friday from 10 a.m. to 5 p.m. and Saturday from
10 a.m. to 3 p.m.

Old objects, prints, and funky-retro abstract paintings fill this fun shop with
custom framing service in the back ground. On view is work by local charcoal
artist Ailyn Hoey and abstract landscapes by oil painter Nancy DuPont Fitz-
Rapalje. Abstract, mixed media artist Stephen Zeigfinger works and exhibits
out of part of the space when he is not traveling.

ART AND HEALTH CARE

Health Center at Bellows Falls

18 Old Terrace (Route 121)
Bellows Falls 05101
(802) 463-1346

Local artists exhibit their work on the walls of the lobby.

Hunter Gallery

30 The Square
Bellows Falls 05101
(802) 463-3669
www.hunter-studio.com
The Gallery's hours are random, but owner Charlie Hunter is often there.
Appointments are welcome.

The Hunter Gallery is in part of what once was the Hotel Windham in down-town Bellows Falls. Charles Hunter's work reflects what he cares about. "Farm animals and rusting infrastructure deserve our attention." With a background in sign painting and graphic design, Hunter creates "Travel Posters That Never Were;" nostalgic advertisements for real places that were never travel destinations, like Bellows Falls or Keene, New Hampshire. He also paints farm animals and rusting infrastructure, from radiators to scenes of Bellows Falls and Springfield. Many of the works are available as giclee prints.

The Exner Art Block

7 Canal Street
Bellows Falls 05101
(802) 463-9444
www.ramp-vt.org

The Exner Art Block is a piece of creative economic development spearheaded by Rockingham Art and Museum Project. RAMP took a building that was dormant for sixty years and brought it back to life as a retail and residential complex. The pressed-tin building houses RAMP's Exner Block Gallery, DNA (Defining New Art) Gallery, African Woven Arts, and Coyote Moon Jewlery & Imports. The ten apartments in the building are reserved for working artists.

ART AND LITERATURE

Village Square Booksellers

32 The Square
Bellows Falls 05101
(802) 463-9404
www.villagesquarebooks.com
The bookstore is open every day from 9 a.m.

Village Square Booksellers is one of the sponsors Bellows Falls' Third Friday Art Walk. Art is always on display and the store hosts special visual and performance art events during the Gallery Walk.

Putney

The Gallery
at the Michael S. Currier Center

Putney School
Elm Lea Farm, 418 Houghton Brook Road
Putney 05346
(802) 387-5566
www.putneyschool.edu/currier/index.html
Please call for hours.

The Putney School is an independent, co-educational boarding school founded in 1935 by Carmelita Hinton, a pioneer in progressive education. Its educational style is less competitive than standard public high schools. The program is college-prep, but the curriculum is designed to foster creativity, intellectual curiosity, and a continued desire for learning. The student body has members from all over the world. The school also has a state-certified working farm, with cattle, milking cows, horses, oxen, sheep, pigs, turkeys, and laying hens.

The arts are an essential and required part of the learning experience at Putney. In 2004, in anticipation of its 70th anniversary, the school constructed the Michael S. Currier Center, which serves as both a performing and visual arts center for the faculty and students. When the center opened, the gallery showcased the art of 70 alumni artists, many of whom have achieved international recognition. Exhibitions include work by nationally recognized artists, students and alumni, as well as exhibits of work from the private collections of alumni.

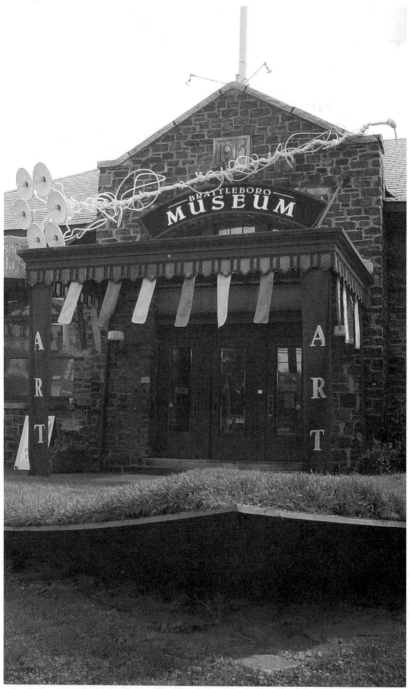

Brattleboro Museum and Art Center.

Brattleboro

Brattleboro Museum & Art Center

10 Vernon Street (Route 142)
Brattleboro 05301
(802) 257-0124 - fax (802) 258-9182
www.brattleboromuseum.org
The galleries are open daily May through February, except Tuesday, from 11
a.m. to 5 p.m. Also open on Memorial Day, Labor Day, and Columbus Day.
Closed Independence Day, Thanksgiving, Christmas and New Year's Day.

The Brattleboro Museum and Art Center (BMAC) presents contemporary art
in Brattleboro's Union Station, which was constructed in 1916. Passenger
trains stopped coming to Brattleboro in 1966 and the building began to
deteriorate. It was sold to the town and came close to demolition when the
BMAC was founded in 1972. The building was the first building in Brattleboro
given the distinction of being listed on the National Register of Historic
Places. It is a non-collecting museum with six galleries with frequently chang-
ing exhibitions. The exhibits feature artists from the Brattleboro region, such
as Donald Saaf and Julia Zanes, Emily Mason, Ed Bartlett, a group of
Vermont-based comic book artists, the Wingate Studio, Patricia Carrigan, and
Michel Moyse. BMAC has also hosted major national exhibitions, such as
2004's *Andy Warhol: The Jon Gould Collection* and 2002's *The American
River*. An admission fee is charged and there is a Museum Shop.

The Artist's Loft

103 Main Street, 3rd Floor (Route 5)
Brattleboro 05301
(802) 257-5181
www.theartistsloft.com
The gallery is open Monday through Saturday from 10 a.m. to 6 p.m. or by
appointment.

Located in the Amedeo de Angelis Building on Main Street. This gallery/bed
and breakfast is the fall, winter, and spring studio home of oil and watercolor
painter William H. Hayes. Hayes paints New England landscapes and scenes
from the coasts of Maine and Nova Scotia and displays them in a salon setting.

Brooks Memorial Library

224 Main Street (Route 5)
Brattleboro 05301
(802) 254-5290 - fax (802) 254-2309
www.brooks.lib.vt.us
The Library is open Monday and Wednesday from 10 a.m. to 9 p.m; Thursday and Friday from 10 a.m. to 6 p.m.; and Saturday from 10 a.m. to 5 p.m., except summer, when the hours are 10 a.m. to 1 p.m.

Brooks Memorial Library in Brattleboro is the largest public library in Windham County. A multimedia institution, it offers books, magazines, online databases, and Internet access for adults, young adults, and children. Brooks also owns a Fine Arts Collection consisting of some 400 paintings, drawings, photographs, sculptures, rare books, maps, and objects, mostly donated, with the majority dating from the 19th century. A selection from the Fine Arts Collection is on permanent display throughout the building, and a brochure outlining a self-guided walk tour of the artwork is available. In addition, Brooks maintains an active public art and display program, offering local professional and amateur artists a venue to show their work for a period of one to two months.

Catherine Dianich Gallery

139 Main Street (just inside the street-level alleyway entrance to the Hooker-Dunham Building)
Brattleboro 05301
(802) 254-9076
www.catherinedianichgallery.com
The Gallery is open Monday through Friday from 10 a.m. to 3 p.m., most Saturdays, and by appointment.

Down the alley and to the right, through a set of green doors is the Catherine Dianich Gallery, a small professional art gallery that shows contemporary art. Dede Cummings and Catherine Dianich Gruver founded the gallery in 2004 in the former Dunham Brothers shoe factory. Their inaugural show was of work by artists with studios in the Hooker-Dunham Building. The goal of the gallery is to be a showplace for established and emerging artists working from the local to the international level.

Gallery in the Woods #2

145 Main Street (Route 5)
Brattleboro 05301
(802) 257-4777
www.galleryinthewoods.com
The Gallery is open daily 11 a.m. to 5:30 p.m. Shows open the first Friday evening of each month, year round, from 5:30 to 8:30 p.m., with receptions for the featured artists.

Gallery in the Woods features three floors of visionary, surrealist, folk, and outsider painting, fine craft, sculpture, furniture, and jewelry from Vermont and around the globe. This is the Brattleboro branch of the original Gallery in the Woods in Marlboro, listed on page 194.

Gallery 2
at Vermont Artisan Designs

106 Main Street (Route 5)
Brattleboro 05301
(802) 257-7044 - fax (802) 257-3049
www.vtartisans.com
The Gallery is open Monday through Thursday and Saturday from 10 a.m. to 6 p.m.; on Friday from 10 a.m. to 7 p.m.; and on Sunday from 11 a.m. to 5 p.m.

Gallery 2 at Vermont Artisan Designs features works of established regional artists and sculptors in a series of individual showrooms around a central gallery. At least one new exhibit is featured each month. Gallery 2 is above Vermont Artisan Designs, a fine craft gallery representing over 350 craftspeople.

73 Elliot

73 Elliot Street
Brattleboro 05301
(603) 256-6989
Call for hours.

This studio and gallery space features work by Arthur Campbell, Leonid Filimonov, K.C. Pearson, and Casey Parris.

Hooker-Dunham Theater & Gallery

139 Main Street, at the end of the alley and down the stairs
Brattleboro 05301
(802) 254-9276
www.hookerdunham.org
The Gallery is open weekdays from 8:30 a.m. to 4 p.m., during events, and
by appointment.

Before Wild Root Arts took over this 3,000-square foot space and turned it into
a theater and gallery in 1999, it was part of what had been the Dunham Shoe
Company warehouse and a small cinema. Since then over 40 exhibits have
been mounted in the gallery and it is a major stopping point on Brattleboro's
monthly Gallery Walk. The gallery, which also serves as the theater lobby, is
1,200 square feet and shows works in two and three dimensions. There is also
a Youth Gallery that showcases work by teens and young adults. Visible in the
gallery space is a mix of construction materials-beams, brick, granite, and the
building's old sprinkler system. Annual shows include a show by the In-Sight
Photography Project and Retreat Healthcare's patient show. Individual shows
have included photographers Alice MacKenzie and Peter Miller and painters
Leslie Anderson and Cosima Hughes.

Latchis Theater

48 Main Street (Route 5)
Brattleboro 05301
(802) 254-1109 x2
www.latchis.org and www.latchis.com
Art is shown in the lobby and the main theater during the monthly Gallery
Walk from 5:30 to 6:30 p.m.; otherwise, as movie patrons and by appointment.

On the corner of Main and Flat Streets, the Latchis Theater is set to become a
first-rate center for the arts. In March 2003, the Preservation Trust of Vermont
teamed up with the Brattleboro Arts Initiative to purchase the historic building.
In addition to restoring the theater, future plans include space for artist studios
and classrooms. It currently exhibits work by local artists in the lobby during
the Gallery Walk and movie presentations. The building itself was constructed
in 1938 as a 60-room hotel and ballroom, 1,200-seat movie theater, dining
room, gift shop, and coffee shop. It is one of only two Art Deco buildings in
Vermont. It still serves as one of Vermont's only remaning downtown hotels
and is home to a three-screen movie theater and the New England Youth
Theater.

Mindspring Galleries

10 Canal Street (corner of South Main Street)
Brattleboro 05301
(802) 922-1406
www.mindspringgalleries.com
The Galleries are open Friday and Saturday from 12 noon to 8 p.m.; Sunday
from 12 noon to 5 p.m.; and by appointment.

Located at the same end of town as the Brattleboro Museum and Art Center,
Mindspring Galleries features the work of photographer M.E. Stanton, painter
Holliday, photograpeher Dorothea Kehaya, ceramic artist Dan Gehan, and
fractal artist Dave Younger.

Renaissance Fine Jewelry and Gallery

141 Main Street (Route 5)
Brattleboro 05301
(802) 251-0600
RenaissanceFineJewelry@verizon.net
The Gallery is open Tuesday through Friday from 10:30 a.m. to 6 p.m. and
Saturday from 10 a.m. to 4 p.m. Extended hours to 9 p.m. on the first Friday of
the month for the Gallery Walk.

This family-owned jewelry store and art gallery specializes in handmade,
custom, estate and designer jewelry and fine silver. The ever-changing displays
of art are well-presented on moldings behind the jewelry cases.

Studio G

Top Floor
59 Main Street (Route 5)
Brattleboro 05301
(802) 254-6833

Up two flights of creaky stairs, one finds themselves on landing of this apart-
ment building-cum-art space.

River Gallery School

127 Main Street (Route 5)
Brattleboro 05301
(802) 257-1577
www.rivergalleryschool.com
The gallery is open Monday through Friday from 9 a.m. to 5 p.m. and during evening classes from 6 to 8 p.m.

In The Art Building on Main Street, and up a flight of stairs, you'll find a small gallery space run by the River Gallery School. The building also houses the River Gallery School's classrooms and some artist studios. The gallery shows a selection of artwork by class participants. A non-profit educational organization founded in 1976, The River Gallery School "is based on the belief that each person has artistic and creative capacities which, when nurtured, will find unique and valuable expression."

Robert H. Gibson River Garden

157 Main Street (Route 5)
Brattleboro 05301
Information booth staffed daily from 11 a.m. to 4 p.m. and during the Gallery Walk.

An underutilized resource in the center of Brattleboro, the River Garden hosts informational exhibits by local artists and arts organizations. The building is organized by the Alliance for the Arts (AFTA) and is staffed daily and during the Gallery Walk. Walk through to the back and enjoy a leafy area with benches that overlooks the Connecticut River.

ART AND MONEY

Edward Jones

225 Main Street (Route 5)
Brattleboro 05301
(802) 257-4144

The Brattleboro office of investment firm Edward Jones is a regular participant in the Gallery Walk. Works by local artists are displayed in the windows and the reception area and are changed monthly.

Vermont Center for Photography

49 Flat Street (behind Sanel Auto, down the alley alongside the Transportation Center)
Brattleboro 05301
(802) 251-6051
www.vcphoto.org
The Center's gallery is open Thursday through Saturday from 1 to 6 p.m.

The Vermont Center for Photography (VCP) is a non-profit that promotes the photographic arts through exhibitions and education. Eric Slayton founded the VCP's predecessor, the Flat Street Gallery, in 1999. A restructuring into a non-profit produced the organization in 2001. VCP's monthly exhibits are premiered at Brattleboro's Gallery Walk. VCP also offers workshops, exhibiting artist talks, portfolio critiques, and professional darkroom rental. Artist exhibits have included work by Sara Andrews, Eric Slayton, Victoria Blewer, Jon Tobiasz, Len Seeve, Jeffrey Lapid, and Christine Triebert. The gallery represents photographers from Vermont, New Hampshire, and Massachusetts.

Windham Art Gallery

69 Main Street (Route 5)
Brattleboro 05301
(802) 257-1881
www.windhamartgallery.com
Thursday and Sunday from 12:00-5:00, Friday from 12:00-7:30, and on Saturday from 10:00-5:30. Other times by appointment.

This storefront collaborative art gallery in operation since 1989 is a project of the Arts Council of Windham County. Members curate exhibitions and run the gallery. Work runs the gamut from new to established artists, traditional to experimental work. Their website has a list of exhibitions for the year as well as member and volunteering information.

ART AND ACCOMODATION

Best Inn

959 Putney Road (Routes 5 and 9)
Brattleboro 05301
(802) 254-4583
www.americasbestinns.com

The Best Inn on Putney Road presents work in its lobby as part of the Gallery
Walk. Works on display have included drawings by Andrew Chardain and
paintings by Katy Hughes.

ART AND HEARTH

Friends of the Sun

532 Putney Road (Routes 5 and 9)
Brattleboro 05301
(802) 254-4208
www.friendsofthesun.com

Friends of the Sun is a provider of home and hearth products. A regular stop
on the Gallery Walk, the store has shown the work of such artists as landscape
artist Judy Hawkins and integrates the work into its room setting displays.

ART AND SHOPPING

A Candle in the Night

181 Main Street (Route 5)
Brattleboro 05301
(802) 257-0471
www.acandleinthenight.com
The shop is open Monday through Thursday and Saturday from 10 a.m. to 6
p.m.; Friday from 10 a.m. to 8 p.m.; and Sunday from 12 noon to 5 p.m.

A Candle in the Night describes itself as a "different kind of oriental rug
and furniture store." One aspect of that difference is its in-house art gallery,
which features rotating monthly exhibits and is a stop on Brattleboro's Gallery
Walk.

ART AND FOOD

Amy's Bakery Arts Café

113 Main Street (Route 5)
Brattleboro 05301
(802) 251-1071
The Café is open Monday through Saturday from 8 a.m. to 6 p.m. and on
Sunday from 9 a.m. to 5 p.m.

Amy's Bakery Arts Café offers monthly art shows and river and mountain
views. Amy's is a full bakery with everything made from scratch, including
artisan breads, cakes for all occasions, cookies, pastries and lunch, including
soups, salads, sandwiches, and gourmet coffees and teas. Amy's is a regular
stop on the Brattleboro Gallery Walk and features individual and group shows
by local artists and themed shows, such as 2005's *The Art of Breastfeeding*,
which was presented in partnership with the Catherine Dianich Gallery.

Collected Works & Café Beyond

29 High Street (Route 9)
Brattleboro 05301
(802) 258-4900
www.collectedworksbooks.com

Featuring books and food, Collected Works and Café Beyond also shows
works by Brattleboro-area artists.

Max's Restaurant
1052 Western Avenue (Route 9)
Brattleboro 05301
(802) 254-7747
The Restaurant is open for dinner Wednesday through Sunday.

Max's serves a fusion of Italian and American cuisines in a bistro-like setting. Monthly art exhibits rotate featuring Vermont, national and international artists.

Metropolis Wine Bar
55 Elliot Street
Brattleboro 05301
(802) 254-1221
www.metropoliswinebar.com
The Metropolis is open nightly starting at 5 p.m.

Describing itself as a "purveyors of cool since 2003," the Metropolis is a Gallery Walk destination, serving wine, small bites, cocktails and work by artists the likes of Doug Trump.

Mocha Joe's Café
82 Main Street (Route 5)
Brattleboro 05301
(802) 257-7794
www.mochajoes.com
The Café opens daily at 7:30 a.m.

This cozy, comfy spot has great coffee and rotating art exhibits on the walls.

Thirty 9 Main
39 Main Street (Route 5)
Brattleboro 05301
(802) 254-3999
www.thirty9main.com
The restaurant is open Thursday through Monday from 5:30 p.m. to close

The ceiling of this small restaurant has a skylight that runs through the entire space. They exhibit work by local artists.

Riverview Café

36 Bridge Street (Route 119)
Brattleboro 05301
(802) 254-9841
www.riverviewcafe.com
The Café is open seven days a week. Call for seasonal hours.

The Riverview Café has both indoor and outdoor seating (weather permitting) and has rotating shows of art by local artists and photographs of life on the Connecticut River and Island Park from days past.

Twilight Tea Lounge

51 Main Street (Route 5)
Brattleboro 05301
(802) 254-8887
www.twilighttealounge.com
The Tea Lounge is open Tuesday through Thursday from 2 to 10 p.m.; Friday from 2 p.m. to 12 midnight; Saturday from 12 noon to 12 midnight; and Sunday from 12 noon to 8 p.m.

The Twilight Tea Lounge offers over 120 varieties of teas and herbal blends and a variety of treats. Each month a new exhibit by a local artist is displayed. Thursday evenings showcase musical and literary events.

WeatherVane Gallery and Club

19 Elliot Street
Brattleboro 05301
(802) 246-2560
This "art bar" is open Monday through Friday from 4 p.m. to 2 a.m. and Saturday and Sunday from 10 a.m. to 2 a.m.

Like the Metropolis, the WeatherVane is a bar that has a major art component, as well as live entertainment.

McNeill's Brewery

90 Elliot Street
Brattleboro 05301
(802) 254-2553

Brattleboro's own microbrewery, McNeill's features beer and rotating art shows.

Marlboro

Drury Art Gallery
at Marlboro College
2582 South Road
Marlboro 05344
(802) 257-4333
www.marlboro.edu/community/drury_gallery/
The Gallery is open Sunday through Friday from 1 to 5 p.m. while the college is in session.

The Drury Gallery was designed by architectural sculptor Michael Singer while he was a visiting artist at Marlboro College. Exhibits by students and faculty as well as national and international artists are on rotating display throughout the year. The publication *Marlboro This Month* and the college's website provide an up-to-date listing of installations in the gallery.

Gallery in the Woods
1825 Butterfield Road
Marlboro 05344
(802) 464-5793
www.galleryinthewoods.com
The Gallery is open daily in summer from 10 a.m. to 5 p.m. and in winter by chance or by appointment.

The original Gallery in the Woods features visionary, folk, outsider, and surrealist painting, craft, furniture and sculpture from Vermont and around the world. The gallery highlights pieces from their shows during the year, and exhibit outdoor sculpture in their gardens. Gallery in the Woods #2 is in downtown Brattleboro, listed on page 185.

Patrick Johnson Studio
1836 South Road
Marlboro 05344
(802) 257-0922
www.abstractfigurativesculpture.com
The Studio is open 9 a.m. to 5 p.m., by appointment for your convenience.

Patrick Johnson has a variety of work including clay and mixed media sculpture combining figurative and landscape elements. Also, non-functional pottery and animal sculpture can be seen at his studio and on his website.

Events in Connecticut River

YEAR-ROUND
Third Friday Art Gallery Walk, Bellows Falls
Downtown Bellows Falls
(802) 463-9404
www.villagesquarebooks.com/3rdfridayartwalk.htm
Every third Friday of the month, from 5 to 8 p.m., the art galleries of Bellows Falls, along with other participating downtown businesses, host an art gallery walk. A map, available at the Village Square Booksellers website and in the store, is a great guide to galleries and other art-related businesses in Bellows Falls.

YEAR-ROUND
Gallery Walk, Brattleboro
Downtown Brattleboro
(802) 257-7044
www.gallerywalk.org
An increasing number of galleries, studios, and other exhibitors throw open their doors the first Friday of each month in Brattleboro for Gallery Walk. This fun and festive stroll is from 5:30 to 8:30 p.m. If you can't make the first Friday event, pick up a copy of the Gallery Walk Guide, which also serves as a great resource for what's going on in the area for the month.

AUGUST
Canal Street Art Fair, Bellows Falls
Exner Block, Canal Street, Downtown Bellows Falls
(802) 463-3252
Held as part of Rockingham Old Home Days in early August and sponsored by the Rockingham Art and Music Project (RAMP), the Art Fair turns Canal Street into a pedestrian mall with arts and crafts and live performances and demonstrations.

OCTOBER
Festival 05301, Brattleboro
Throughout Brattleboro
www.festival05301.org
Held at the end of September and through October, Festival 05301 is a celebration of the arts in Brattleboro, which was named one of the nation's top ten small arts communities. Activities include musical and dramatic presentations, as well as visual art displays.

OCTOBER
October Festival of Arts and Village Arts Gallery, Putney
114 Westminster Road
(802) 387-8548
www.villageartsofputney.com
Village Arts of Putney provides art instruction throughout the year in what is known in the village as the "Yoga Barn". In October, a seasonal art gallery is opened every Friday through Sunday for the month. In addition, special classes are offered during the month.

NOVEMBER
Putney Craft Tour, Putney
Putney, Westminster West, and Saxtons River
(802) 387-4032
www.putneycrafts.com
Held the Friday, Saturday and Sunday after Thanksgiving from 10 a.m. to 5 p.m.
The Putney Craft Tour is the oldest continuing craft tour in the United States. Twenty-five artists and artisans open their studios and you can see them work and speak with them. Studios include not only glass blowing, pottery, ceramics, painting, photography and sculpture, but also cheese making, blacksmithing, furniture making, and bookbinding, among others. The website has a map of the tour and information about lodging and accommodation.

STATEWIDE

Here, we have included one organization and one event that operate statewide, but do not have a particular venue associated with them.

VSA Arts of Vermont

Suite 7
20 Canal Street
Winooski 05404
(802) 655-7772
www.vsavt.org

VSA Arts of Vermont, formerly Very Special Arts Vermont, was founded as a non-profit organization in 1986 with the mission to make arts accessible to Vermonters of all ability.

"The letters VSA, which have stood for Very Special Arts, now stand for Vision of an inclusive community, Strength in shared resources and Artistic expression that unites us all. The mission of VSA Arts of Vermont remains the same: to bring the power of the arts to Vermonters of all abilities."

At 50 locations throughout the state, VSA VT provides free weekly arts programs to 4000 low-income and disabled children, families, and adults. Art includes everything from puppetry to poetry, drama, drumming, dancing, murals, painting, and more. VSA VT produces exhibitions at a variety of art venues around the state.

Event Statewide

MAY
Vermont Open Studios Weekend, Statewide
(802) 223-3380
www.vermontcrafts.com
Held over Memorial Day Weekend, everyday from 10 a.m. to 5 p.m., artists and artisans from across Vermont open their doors to the public. Order a map online at the Vermont Crafts website or pick one up at a Vermont Welcome Center and get an early start. There's a lot to see. Open Studios Weekend is a unique opportunity to visit artists' studios, many of which are not open to the public during the rest of the year. If you are buying or ordering work during the weekend, you have an opportunity to speak to the artists directly.

Index

About the Authors

photo credit: Dan Grant

Ric Kadour is the Vermont Regional Reviews Editor of *Art New England* and a freelance writer whose work has appeared in a number of publications including, *Vermont Magazine, Champlain Business Journal, Seattle Weekly, The Stranger,* and *Salt Lake Metro.*

photo credit: Ric Kadour

Christopher Byrne is a former non-profit association executive and conference planner. Early in his career, he co-edited a directory of professional programs and other publications. He excited about getting back into writing and editing.

You may contact Ric or Chris through Kasini House:

Kasini House
PO Box 1025
Burlington, VT 05402
info@kasinihouse.com
www.kasinihouse.com